Art in East Africa

A Guide to Contemporary Art

Artists in East Africa

Fatmah Abdullah
Abdulhamid Abshehe
Tag Ahmed
Abdala Ajaba
Pajuma Alale
Robin Anderson
Joanna Babault
Mordecai Buluma
Bakari Bwanakanga
Alan C. Chappell
Paulo Chege
Anesta Chibanga
Clemente
Nani Croze
Ali Darwish
Bhupendra Desai
Destani
John Diang'a
Rena Fennessy
Cajie Fernandez
Jany Gastellier
Paul Githinji
Robert Glen
Catherine Gombe
Abdulahi Halake
Hatesi
Terry Hirst
Elias Jengo
Harper Johnson
Norbert Kaggwa
George Kakooza
Ed Kalule
Augustine Kalyamagua
Munuhe Kareithi
Rosemary Karuga
Martin Luther Kasirye
Jak Katarikawe
Joseph Katembo
Nganga Kiarii
Timothy Kidiga
Jonathan Kingdon

Andrew Kiwanuka
Israel Kiyame
Tom Kiyegga
Mary Kreuger
Brother Anthony Kyemwa
Eli Kyeyune
Philip Lasz
Wilson Likenga
January Linda
John Lyimo
Godfrey Makonzi
Francis Malinda
Gregory Maloba
Shem Maluka
Betty Manyolo
Terry Mathews
Severino Matti
Theophilus Mazinga
Simon Mboga
Luis Mbughuni
Gentle Joseph Moko
Alphonse Moto
Albert Msangi
Francis Msangi
Tomas Mtundu
Mugalula Mukiibi
Albert Mulembo
Mutisia Munge
Francis Musango
Therese Musoke
Mwambete Mutisia
Simon Mwangi
Louis Mwaniki
Omari Mwariko
Simon Mwasa
Edoarde Nangundu
Joseph Ndumu
Francis Ndwiga
Asaph Ng'ethe
Kamau Ngugi
Harald Nickelsen

Kiasi Nikitiwie
Elimo Njau
Rebeka Njau
Edward Njenga
George Njuguna
Livingstone Nkata
Francis Nnaggenda
Sam Ntiro
Gard Okello
Flora Omare
Elkana Ong'esa
Joel Ombasa Ong'esa
Mzee Moseti Orina
Hezbon Owiti
Ali and Maya Panga
Ian Pritchard
Giselle Rocco
Sister Mary Lou Rose
Thomas Salyeem
Samaki
Thelma Sanders
B. P. Sanka
Dorothy Sekadda
Mathias Semiti
George Sempagala
Kefa Sempangi
Gideon Senyagwa
Tara Shah
Ancent Soi
John Somola
Pilkington Ssengendo
Ignatius Sserulyo
Peter Sweverta
Eduardo Tingatinga
Leslie Thomsett
Sefania Tunginie
Jony Waite
Samuel Wanjau
Katongole Wasswa
Juma Waziri
Elfas Webbo

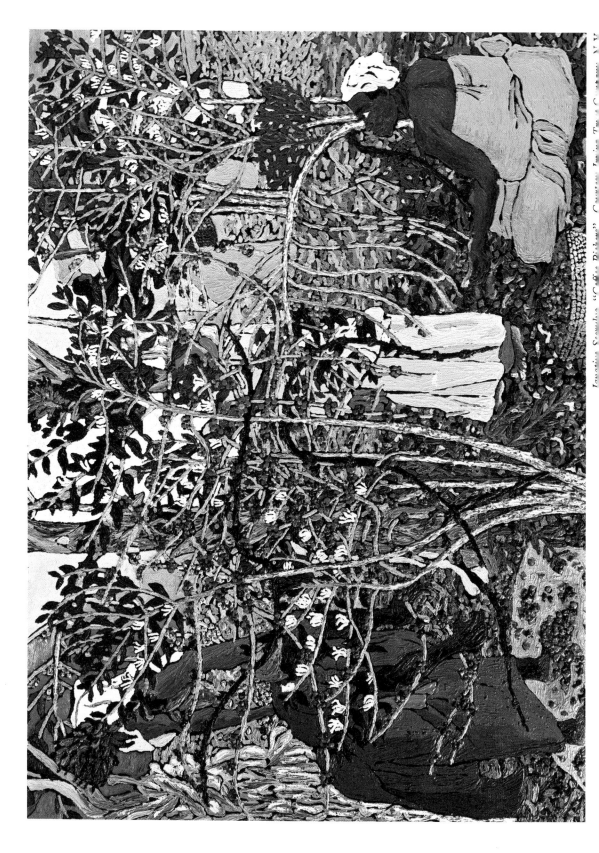

ART IN EAST AFRICA

A Guide to Contemporary Art

JUDITH VON D. MILLER

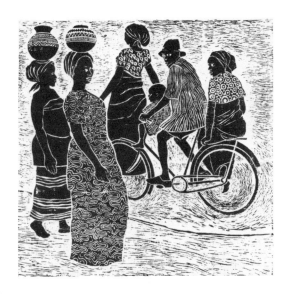

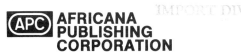
AFRICANA PUBLISHING CORPORATION
101 Fifth Avenue, New York, N.Y. 10003

Nairobi

First published in Great Britain in 1975 by Frederick Muller Ltd, London NW2 6LE

Africa Book Services (EA) Ltd P.O. Box 45245 Nairobi

Copyright © 1975 Judith von D. Miller

ISBN 0 584 10154 6

I acknowledge with thanks all those people in East Africa who returned my questionnaires, answered letters, contributed photographs and supplied information in interviews. In particular I was most grateful for the assistances of the Faculty at the Makerere School of Fine Arts. Special thanks go also to friends and family who have been helpfully critical and encouraging and especially to my husband, Norman, who inspired me to write the book and whose perseverance brought about its publication.

JUDITH VON D. MILLER

Cover, Francis Nnaggenda, "Woman". Photo Ramesh Shah, courtesy Kenya Shell Ltd.

Title Page, Gard Okello, "Passers By"

Printed in Great Britain by Whitstable Litho Limited

Preface

It is always a pleasure to help encourage any form of art and particularly African art. It is therefore with the greatest pleasure I have accepted to write this preface to Judy Miller's comprehensive book on art in East Africa.

Judy has had a long association with art, having worked as a writer and editor at The Museum of Modern Art in New York. She developed an interest in contemporary art as a result of her association with that museum. She had her first glimpse of contemporary African art in 1968 when The Museum of Modern Art held an exhibition of African stone sculptures from central Africa. She left the Museum in 1969 and managed a gallery of contemporary African art from central Africa. She is well qualified to write on the subject of East Africa after her subsequent five years of research and writing in Kenya, Tanzania and Uganda in preparation for this book.

The time has come to establish some record, as a "Who's Who" of East African art. Judy has supplied this need. This record of art in East Africa will be of value to future art lovers who would like to know something of the background of artists and the environment in which they developed.

I cannot let this opportunity pass without a word about present-day African art. It is going through a transitional period which should be understood. Old African art, which is highly prized by collectors today, is, alas, fast dying out. William Fagg of the British Museum, a great authority on African art, says, "We are in at the death of all that is best in African art". This is perhaps true, as the motivation behind old African sculptures (which were orientated towards religion) is fast dying out. Today the traditional patrons have lost their power. The rituals which inspired that art exist no more. Western civilization has changed that. In its place we find a profusion of art developed almost wholly for the tourist trade. But apart from this there is now developing a new trend in African art—new in character and expression. This, together with new forms of expression in literature, etc., must be accorded every encouragement.

This book amply records this new trend. I hope the book will be of value to those today who want to understand African art and to those in the future who would like to know "Who was Who" in that field.

<div align="right">JOSEPH P. MURUMBI</div>

Joseph Murumbi was Vice-President of Kenya in 1966. In the years that followed he retired from politics but remained active in international business affairs, serving as director of several large firms in East Africa. Mr. Murumbi is also a noted art collector and has given enormous support to many East African artists struggling to gain recognition in their profession. He is Chairman of the Kenya National Art Foundation, which gives scholarships to artists and grants for art classes. With his wife, Sheila, he has opened a unique workshop and outlet gallery for artists known as African Heritage.

Abdullahi Halake. Photo Mohammed Amin

Contents

PART I

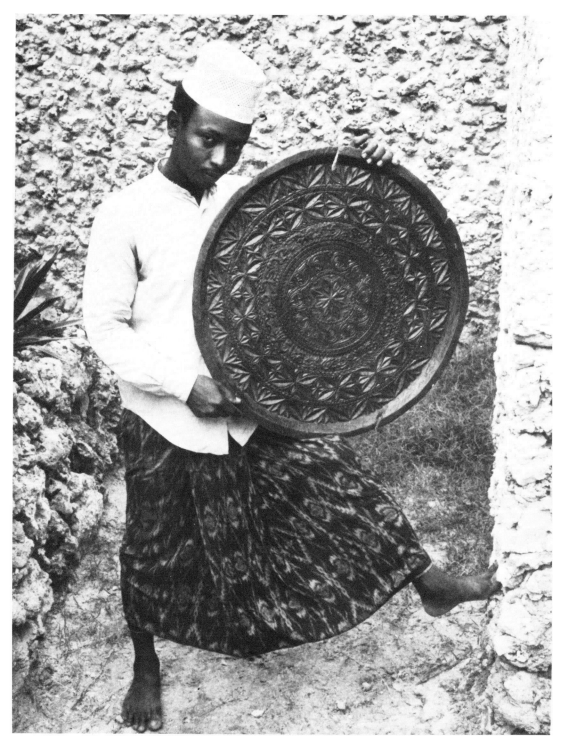

Bakari Bwanakanga. Photo Norman Miller

Artists in East Africa

The work of indigenous artists in East Africa deserves more attention than it has received. A brief sociological analysis of 70 East Africans known publicly as artists reveals them to be, by local standards, an elite group. Two-thirds are university graduates and over half hold white collar jobs in schools, banks, publishing houses or government offices. About one-fifth are blue collar workers and another fifth depend on selling art for an income and could be called free-lance artists. Most find sales very difficult. Very little market exists for contemporary African art, in Africa or abroad.

Of course there are many more artists in Kenya, Tanzania and Uganda than are mentioned here. Some of these work within art movements and are dealt with in Part II. Others are artisans who make traditional ornaments and utensils to specifically-defined tribal designs. To list these people by name and talent is a vast research still waiting to be done, possibly full of surprises for art historians. Works by such artists are appearing in the growing collections of East Africa's three national museums. But the artists themselves remain anonymous and are unknown outside their immediate community.

Only the members of the elite group mentioned above have received any wide public recognition as artists, and most have had only the most ephemeral of artistic careers. Graduates from the Makerere School of Fine Arts represent the best known names, those who have had their works exhibited in art galleries in Africa and abroad. Most of these names have faded from public view after a short time. In East Africa, art is definitely not a cult.

Those with the longest careers as artists have either studied or taught at Makerere University School of Fine Arts. Gregory Maloba was one of the first students of the school's founder, Margaret Trowell. He now heads the Art Department at the University of Nairobi. More recent Makerere graduates Francis Msangi and Louis Mwaniki have been lecturers in Maloba's Department. Sam Ntiro, a Makerere graduate and once acting head of art at Makerere, became the Tanzanian Commissioner of Culture and chairman of three art societies in Dar es Salaam. Graduates who went on to teach at Makerere have been Ali Darwish, George Kakooza, Godfrey Makonzi, Therese Musoke and Kefa Sempangi and at the University of Dar es Salaam, Elimo Njau, Elias Jengo and Luis Mbughuni. Njau has also co-directed two art galleries and owns three others jointly with his wife, Makerere-trained artist Rebeka Njau. Eli Kyeyune, one of the few Makerere graduates to establish a name as a free-lance artist, is engaged in ethnographic research with the Makerere Department of History. Many more Makerere-trained artists hold key positions in other schools and colleges, or are civil servants concerned in some way with the arts. But their names as artists have faded from public view as they find less and less time for private art work. Most admit they reached a peak of activity while on campus as students or teachers.

Careers in art-related professions are not easy to find. Teaching art is the first choice because it gives the best chance of combining work and art. Civil service jobs can be art-oriented, such as supervising school art curricula or designing publicity. Free-lance artists still have some hope in East Africa of finding a patron, but, as anywhere else, the artist risks subjection to the whims of his protector and

patronage is not easy to find. Commissions for art works on public buildings are available, and in Uganda dozens of artists have had the chance to design major murals or statues which are permanently on public view. In Kenya indigenous artists have had difficulty competing with better-known, better-exposed foreign artists who tend to dominate the trade in art in that country. In Tanzania there have been few opportunities to create art works for public buildings. Some government and foundation grants exist for artists in East Africa, but these are usually under such remote auspices artists rarely hear about them or know where to inquire. University artist-in-residence appointments, grants-in-aid, research positions, design work for businesses, scarcely exist at all. Graphic design is a career possibility for a few people and the rare jobs offered by local publishing houses are highly coveted.

Oddly enough, most of the free-lance artists in East Africa are *not* Makerere graduates. One is Hezbon Owiti, a fine lithographer and painter who received acclaim abroad after his art study in Nigeria. He was the only East African mentioned in Beier's *Contemporary Art in Africa* (the first book on that topic) and has been on the cover of the University of California at Los Angeles publication *African Arts*. Painter Jak Katarikawe, once a cab driver in Kampala, now lives by sales of his art and has exhibited in East Africa, Europe and the United States. Makonde carver Pajume Alale has been to Germany, England and Japan under the auspices of the Tanzania Government and sells his work steadily. Bakari Bwanakanga has become successful at selling his woodcarving in Lamu, an island off the coast of Kenya. His customers are both local and foreign. Simon Mwangi works as a fabric designer in Nairobi.

Another curious point is that 52% of the university-trained artists are painters and 52% of those with less education are sculptors. Perhaps sculpture seems more familiar to unschooled African artists. Certainly clay and wood are more easily accessible to them than are paint and paper. Schools, however, supply paint and paper in art classes, and thus painting is often taken up by artists who have had more formal education.

The concept of being an "African artist" hangs heavily over indigenous artists in East Africa. Many of them are more conversant with western art forms than with African traditional art. Like the countries in which they live, their modern identity is the product of many influences. But an artist is more concerned about his professional than racial reknown. Far better to be thought of as an "artist" who is an African than an "African" who is an artist.

Individual Artists and Their Work

To Westerners, artists in East Africa probably seem old-fashioned. Such trends as op, pop, kinetic, hard-edge and minimal art have little following. Neither do African artists subscribe to such formal Western "schools" as Abstract Expressionism, Cubism, Impressionism or Surrealism, although an Individual's work may utilize forms attributable to one of these. Because of its unmodishness, African art has rarely been considered modern by Western art critics. At most it is described as the dissipation of a once-vital traditional art. Legendary pronouncements have been made by well-known critics and artists: "There is no art in East Africa". "There has been no art at all in Africa for the past 80 years". "L'Art Negre, n'existe pas".

As partial explanation for this unmodishness, and completely leaving out the very real personal philosophical objections of African artists to the Western modern art scene, it should be understood that few artists in Africa have access to the latest media in which so much experimentation is carried out abroad. Brush and canvas, which became at one time almost obsolete in Europe and America, are among the only materials available in East Africa. Sculptors may use clay, wood or stone, but only a few of the enterprising or privileged work in metals. Financial restrictions are very real. A student at a major art school is allotted 200/= a year for supplies. This is scarcely enough to allow him many orthodox works, let alone experimentation with polyethylene.

However, in the West, the development of new

materials has sometimes proved as much a restriction as a liberation, precluding styles which do not require a significant innovation in media and methods. And, this artistic evolution is certainly not always responsible for the best in art, nor is it the only valid idiom today. In Africa, where the new technology in art is still a minimal imposition, naturalistic art forms can be most meaningful. What happens overseas is irrelevant. The great opportunity provided by circumstances to the artist in Africa is that all artistic options are, at least philosophically, still open.

What, then, is the art of modern Africa? A close scrutiny reveals that its conscious mind is very well aware of the rest of the world; but its subconscious roots are in a heritage more ancient than history has been able to record. Take for instance, Nnaggenda's "Spirit Within Man". The artist is the product of a European education. He uses an old saw blade, nails and painted wood

in a monumental-sized sculpture, much as any ambitious sculptor abroad. But the faces on the sculpture are African and the concept of an immense head as the "seat of the spirit" is an old, old African idea.

Perhaps painting is the greatest anomaly in Africa. Excepting the ancient Bushman cave paintings, Islamic and Coptic art, painting can be considered comparatively new in Africa—appearing, say, within the past half century. Styles in painting are thought to be more influenced by Western art than are styles in sculpture. Still, what emerges is uniquely African.

Prevalent is a style somewhere between realism and abstraction which can be called "expressionism". In these paintings the objects and figures are recognizable but also become important design elements. In Ssengendo's "Night" a trailing garment blends with the curve of the road and the eyes of the figure are in the same relation

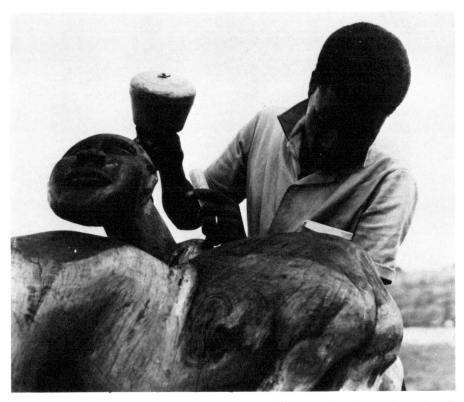

Abdullahi Halake. Photo Mohammed Amin

15

to the rest of the painting as are the eyelike windows of the house. The staff, the only vertical or straight line, provides a focus in the midst of the other swirls and curves. Similarly, in Ntiro's "Potato Digging" bending figures are basically ovoid shapes repeated in the potatoes and, in miniature, in the leaves and bushes. An additional refinement to this mode of painting is the placing of the figures into distinct planes on the canvas. In Musango's work, four distinct planes of action are present, from the giant and his beasts in the foreground to figures labouring in the distance. In Abdallah's "The Revolutionary Spirit" the heads are in the lower third of the painting; placards occupy a swath across the centre and the top is filled with trees. The headscarves serve an important decorative function as do the alternating lights and darks of the placards and their lettering. Colours may also be laid on in patterns. Note the rhythmic repetition of yellow, blue, red in the frontispiece, Sserulyo's "Coffee Picking".

The reduction of human shapes to geometric patterns has always been an essential element in African art. At the turn of this century it became the preoccupation of Picasso and the early Cubists in Paris. Neither form is a copy of the other. The Cubists merely happened upon an old idea at another point in history. An artist like Msangi can paint "The Fish", for instance, in a style as reminiscent of Picasso as it is of traditional African art. The same may be said of Mukiibi and Tunginie. The forerunners of today's modern art were Cubists, but cubism with a small "c" was the basis of traditional African art. To claim that any of these artists, European or African, is derivative, is to invite serious disagreement.

Derivations, once suspected, can be found from many other great artistic traditions. Islamic art, which permits no figures and has its own type of patterns, is definitely an influence on the Zanzibari painter Ali Darwish. His works are composed of complex layers of textured patterns.

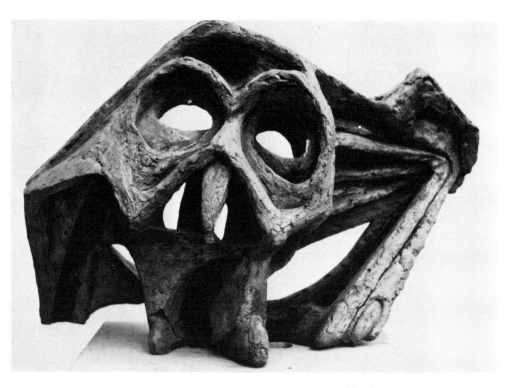

Mugalula Mukiibi, "Owl Janus"

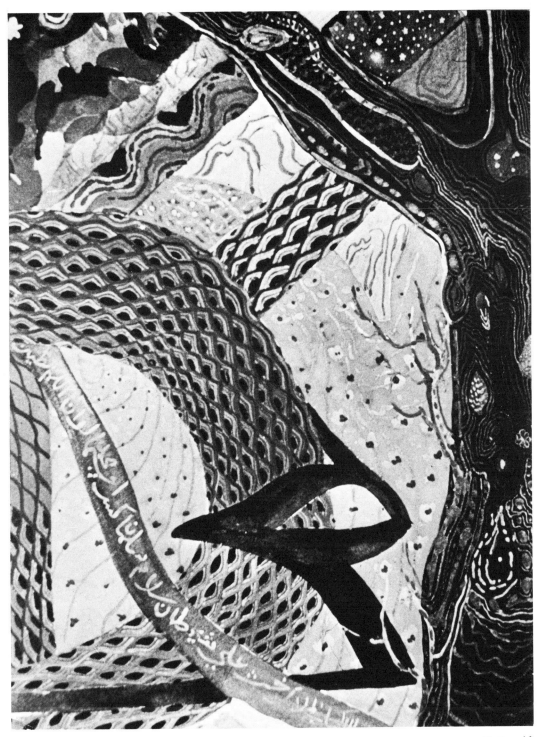

Ali Darwish

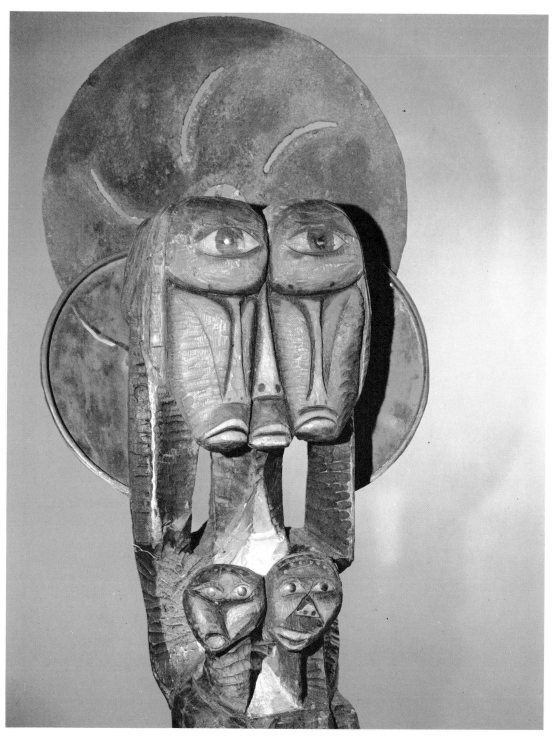

Francis Nnaggenda, "Spirit Within Man"
Photo Ramesh Shah, courtesy Kenya Shell Ltd

The central image may be, perhaps, a tree, super-imposed with a rich detail composed of touches of gold paint and sometimes Arabic or Kufic lettering. African art is, like modern Africa today, the result of many ancient and modern traditions. It is uniquely itself, but composed of elements as much from its own past as from today's global culture.

Printmakers are rare among East African artists, again because of the difficulty in getting the equipment. Linocuts, lithographs and woodcuts lend themselves to the very design elements and repetition of patterns as already seen in East African paintings. So in Okello's linocut "Baganda Dancers" the shapes of arms are repeated in the shapes of leaves and the solid tones of limbs correspond to the solid bands on the dancers' skirts. Manyolo's woodcut "Fable" is a tightly woven bird-frog-snake-fish within an ovoid composition. Each body is intricately patterned, the figures individual but the amount of surface treatment

uniform throughout. Owiti's linocut "The Donkey Rider" departs from the patternistic style; his conception of horse and rider is as modern as it is ancient, reminiscent even of early Celtic or Scandinavian figures. To reduce the elements of the body to geometric shapes is the mainstay of artistic traditions all over the world, as it is the basis of what is called "modern art" today.

Is an African artist more at home as a sculptor than as a painter or printmaker? Perhaps it is easier for him to create a self-image in sculpture. Scenes from everyday life in Africa have become main themes for a number of sculptors specializing in small figurines. Such mini sculptures are the most popular form of art to Africans, who usually do not buy or look at art unless they happen to be artists. Edward Njenga, a social worker in Nairobi, depicts in small statuettes the trials of people struggling with the hardships of city life. In "No Vacancy", job hunters wait outside an office, ignored by a clerk inside. The figures are

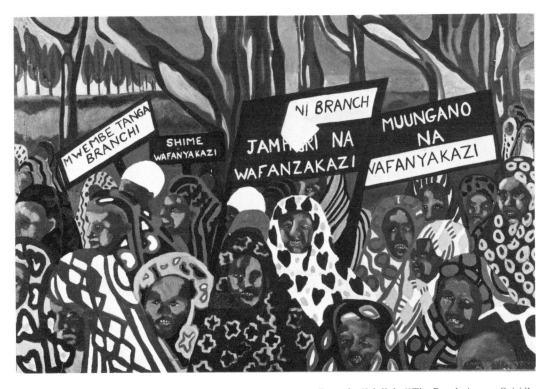

Fatmah Abdallah, "The Revolutionary Spirit"

Francis Ndwiga. Photo Richard E. Beatty

John Diang'a. Photo Daily Nation

placed on a tiny wooden platform, and such props have been used as a coiled telephone cord and wire mesh on the office grid. The clay figures are removable. Njenga plans to set up a small private museum where people can come free of charge to look at his sculptures. He rarely sells his work and is one of the few artists with an indigenous following. Several artists have become quite successful at selling small clay statuettes: John Diang'a's work is illustrated here. Details such as a handkerchief, necktie, bottle and drinking glass have delighted local viewers. Rosemary Karuga's "Kikuyu Woman" is a dignified figure wearing tribal jewellery. The hands are crossed in repose, enlarged, perhaps signifying the woman's large use of them in working, comforting, mothering. Towards a more abstract perception in clay are the sculptures of Damba, Sempangi and Mukiibi, all much larger pieces. Here the style has also been expanded into the realm of symbolism.

Self-image figurines are also seen in other media. Ndwiga was the first to cut little figures from tin sheets. Again the detail is a delightful aspect of the works and common scenes the main theme: a man gets a shoeshine, friends drink together, a woman sifts maizemeal. The proliferation of small wooden figurines from Africa is well-known all over the world and has been discussed in some detail in the section on art movements. Larger sculptures in wood show more individual perceptions, as Mwariko's totem of brusque, masklike faces, Halake's merged man and woman and Ssengendo's figure composed of piled, well-balanced shapes.

The greatest experimentation in styles has taken place in sculpture in stone and metals. Very few artists work in these media (excepting the soapstone Kisii art movement discussed in Part II) as they require specialized tools and equipment such as welding tools. Nnaggenda, Mwaniki and Maloba are among the few working in large sculpture in these difficult media. All of these artists have university positions and access to a greater variety of materials and tools. Nnaggenda likes to work with "found objects" such as camera lenses and sawblades. Mwaniki's "Adam and Eve"

is composed of steel rods and fibres and stone figures. As with much of Mwaniki's work, this sculpture is sophisticated enough to be outside even the broad designation "African art", and indeed could have come from anywhere. Maloba's cement fountain is a more traditional conception, heavy, rounded female shapes with African features and hairdos.

Perhaps the most striking omission in the art of East Africa is the art of social comment. Where does an artist express feelings about African unity, African freedom fighters, African socialism or protest or social comment of any sort? Only a few artists in East Africa have touched on these subjects at all. Most tend to present life as they see it, with no inferences drawn. It seems to point to a degree of fatalism or perhaps a sense of powerlessness, certainly a psychological holding back. Emotions are kept in check, opinions kept inside. Perhaps anger and protest are yet to come.

Mwaniki's "Adam" trapped between steel rods is certainly a forerunner, as is Msangi's "Mother Africa Weeping Over Her Suffering Children".

Among the artists working in East Africa are several who are not indigenous, some of them second- or third-generation citizens of East Africa but originally from the U.K., or long-term residents from the U.S. and Europe. These people work in art forms completely dissimilar in style and subject matter to those by Africans. It was fashionable among colonial artists to paint the different tribes of Africa or the flora and fauna of East Africa. Still today non-indigenous artists tend towards these themes. Rena Fennessy has illustrated many of John G. Williams' bird and game books and designed East African stamps in animal, plant and shell motifs. Robert Glen and Terry Mathews make bronzes of animals and tribal peoples with anatomical accuracy and close attention to detail. Jonathan Kingdon wrote and

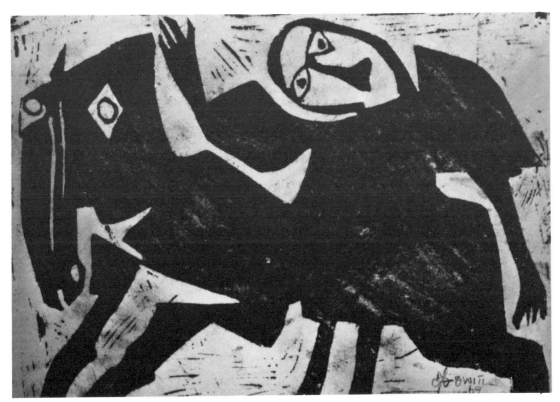

Hezbon Owiti, "The Donkey Rider"

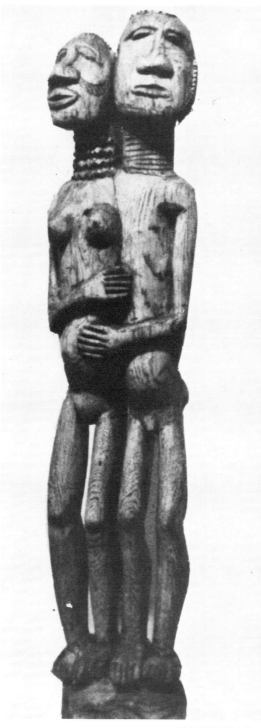

Abdullahi Halake

illustrated the mammoth *East African Mammals: An Atlas of Evolution in Africa.* Joy Adamson's *The Peoples of Kenya* was commissioned by the colonial government. Several visitors to East Africa have become famous abroad for painting animals: David Shepherd, Ralph Thompson and Jonathan Kenworthy. Batiks were first made in East Africa by Robin Anderson, who has taught the technique to many local artists; Leslie Thomsett also specializes in batiks. Jony Waite and Michael Adams have produced a range of work from free-form crochet to large-scale murals. Jany Gastellier designs jewellery and enamels onto driftwood.

Unfortunately, it is the non-indigenous artists living in East Africa who have received the most attention and who engage in the most profitable trade in art. It is a fact that Africans do not buy art and that tourists are attracted to the familiar western-style art gallery found in Nairobi. This tends to leave the indigenous artists out of the competition. Many of them resent the exposure given to European artists and prefer to work alone for a limited audience than to show their works in big-city art galleries. Prejudices acquired over the years are slow to disappear and artists are very sensitive about where they show their works and with whom. Then, too, the main buyers of art in East Africa, the tourists, have pre-set ideas about what they want. The artist who mass-produces sentimental renderings of women with water pots on their heads may sell a lot more than the experimental artist who needs a more thoughtful audience. Indigenous artists for the most part work alone and rarely even meet colleagues except on art school campuses. The East African artist is in the difficult position of having to be his own colleague, audience and critic.

A solution which is often mentioned, with varying reactions, is assistance from the State. East African governments are just beginning to become concerned about preserving and promoting their national cultures. Just what constitutes "national culture" is difficult to decide. The Uganda Government has the earliest record of an

interest in indigenous modern paintings and commissioned Ignatius Sserulyo's "A History of Uganda Medicine". It was presented to W.H.O.'s Offices in Kinshasa on behalf of the Uganda Government. The Tanzania Government has recently opened its National Arts of Tanzania Gallery, which shows only Makonde art, and a precedent of discussing "National Culture" has been established at political rallies. President Kenyatta has allowed himself to be sculpted and painted but so far no official patronage of the arts exists in Kenya.

Perhaps the most pressing need of the artist in East Africa is for considered comment, criticism and reception from a larger segment of the society. Perhaps this book will provide a step towards that end.

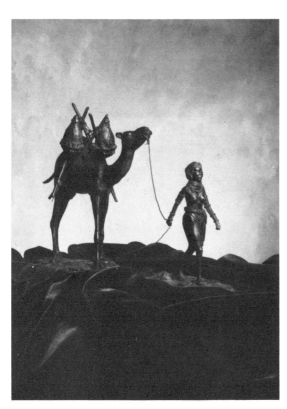

Robert Glen, "Gabbra Woman and Camel"

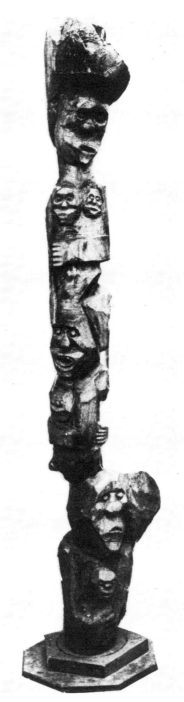

Omari Mwariko

PART II

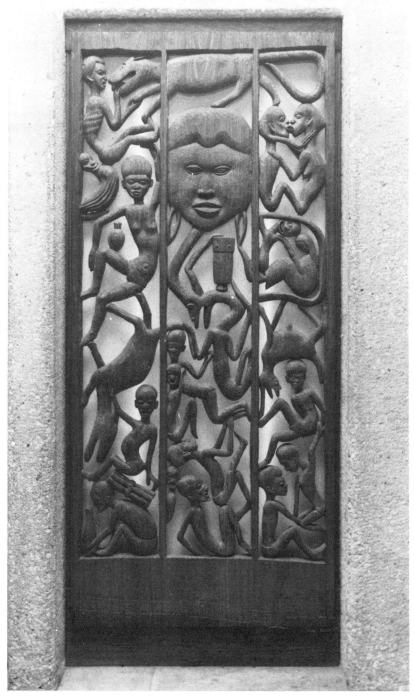

Atesi, Makonde Panel. Photo Shaancolor Studio

Art Movements in East Africa

Few people are aware of the number of East African tribes which have traditionally made art for ceremonial as opposed to utilitarian uses. Margaret Trowell, in *African Design*, describes wooden figurines made by twenty-six East African tribes and clay figurines made by sixteen tribes. Today artists within certain tribes make a different kind of art. It may be either utilitarian or "for art's sake", but is not made for the tribe. It is art made for sale to a wide public. As with traditional art, different styles are produced by different tribes. As before, the artists live and work together and individuals rarely become known by name.

Among the East African tribes which have made art for public sale rather than personal use have been the Gogo, Kamba, Kerebe, Kisii, Makonde, Masai, Nyamwezi, Shambala, Sukuma, Yao and Zaramo. Three of these tribes have developed such distinctive styles of art that they can be termed "art movements". The art is exported all over the world and proceeds support hundreds of artists. The produce may be anything from tiny figurines to large statues or artifacts calculated to find a use in western-style homes.

The traditional bases of these contemporary forms of tribal art are unclear. The Kamba, for instance, have always been great artisans. This is amply evidenced by the variety of calabashes, pots, stools, baskets, jewellery and forged-iron implements still being made for their own personal use. Numbers of these traditional artifacts have been collected for display in the National Museums of Kenya. The spoons, stools and stoppers made in the 19th century and the wooden gargoyle-like figures once used to guard Kamba houses from evil spirits do bear a slight resemblance to the modern Kamba wooden figurines which appeared on the public market around 1914. There is also some evidence in contemporary anthropological research to suggest the carving of wooden masks was once a traditional Kamba art. Such masks may also have been stylistic predecessors of the modern carvings.

The Kisii are known to have made soapstone utensils traditionally, in the form of pots, pipes and bowls. The making of other artifacts for public sale evolved a few years after World War I, as it did with the Kamba. Designs expanded to include animals, people and such modern household items as candlesticks, ashtrays and vases. Both tribes began by selling the new carvings to missionaries and expatriate farmers. Missionaries were a particularly good market as some of them exported huge quantities of "native handiwork". The Kisii line of housewares and statuettes has always been less extensive than that of the Kamba, partly, perhaps, because soapstone is a more limiting medium than wood.

The origins of Makonde carving are much better documented than are those of the Kamba or Kisii, and more easily traceable to traditional art. Makonde lore states the first of their tribesmen was a woodcarver who hewed his mate from a log. The Makonde are a matrilinear tribe and have traditionally carved wooden female images for ceremonial use. The modern wooden statuettes evolved from these, and in the beginning, they too were solely of female figures. Art historians have written extensively about traditional Makonde masks, stools and human figurines. Today modern Makonde carvings are

given more professional respect than are works by the Kamba and Kisii. Art patrons, galleries and museums collect modern Makonde art, but Kamba and Kisii carvings are usually dubbed "airport art". Perhaps one reason for this is that the Makonde rarely repeat a design line for line, although they do utilize similar images and overall design schemes. The Makonde also specialize in larger statues rather than small figurines or household wares.

One of the difficulties in considering the worth of tribal art movements lies in taking into account the method of working. Members of art movements do not work as individual artists. While unique images are often created, much of the work involves copying set patterns, just as traditional African art consists of patterns repeated for generations. But then, as now, this process need not necessarily become static. Occasionally master artists emerge who refine details and make slight alterations in design. And, the need to be individual is not as pressing as it is in the Western world. It is more important for the African artist to represent his own people and to create art that speaks in familiar provincial terms. One can easily distinguish between the art of different tribes, but not necessarily between carvings made a generation apart. Yet it is possible, even with seemingly identical carvings of single tribes, to detect individual styles and to point out master artists. The same can be said of the contemporary commercial art movements. Quite often distinct types of workers are employed, as for instance cutters or finishers, each doing his own treatment to the same work of art. This serves to standardize the art. Artists working alone tend to make more individual renderings of standard designs and to spend more time on details.

Also, motives for working are different for members of modern art movements than they are within traditional tribal art movements. In the latter, artists worked to please the gods, the king or the tribe; incentives were spiritual hope, gifts and praise from tribal leaders and friends. Artists in commercial art movements work for monetary returns from an anonymous public, which is not a very artistically inspiring incentive. One need only work at the lowest level the public will accept. Unfortunately, works of barely passable artistry and minimal attention to detail are still marketable, at certain economic levels. The public exerts little in the way of quality control. This must be managed by some other means. The artist and the entrepreneur are justifiably more interested in making a living than in controlling artistic standards. Incentives for high-quality work are difficult to instill, but can sometimes happen through the efforts of teachers and sometimes by art patrons. Kamba, Kisii and Makonde artists have created personally commissioned works with exciting and unusual results.

For those who do create something unusual or exemplary, the rewards are small. Their produce may attract little attention from entrepreneurs or the public. All works are sold together and it is up to careful buyers to discover art of unique quality among rows of seemingly identical figurines.

Tribesmen could exercise their own quality controls by selling only a limited selection from the entire produce. If only the best were marketed, and the rest discarded, a natural competition among artists would be engendered. Some members of the art movement would be forced to leave artistic production, but could perform some other function related to the commercial enterprise.

Each of the art movements to be discussed has had a unique history of attempts to organize, to set prices and designs and to determine what will be produced and how the work will be done. Each has had enough success to support hundreds of artists by sales of their own works.

Kamba Art

By far the most highly organized and productive art movement in East Africa is that of the Kamba tribe. They create an enormous line of handmade artifacts. The first commercial Kamba carver was supposedly Mutisia Munge, who has taught the trade in Wamunyu, Machakos

District, Kenya, since 1914. His ideas originated, it is said, from the Zaramo carvings he found being made in Tanzania during his career in the Carrier Corps during World War I. His family had been blacksmiths who also made wooden stools. Munge taught them to carve human and animal figurines and housewares, based on the Zaramo models. Soon many of his neighbours left tilling the land around Machakos District to participate in the art movement.

Foreigners and soldiers came in great numbers to Kenya in the 1940s and 1950s and caused a boom in the Kamba carving trade in Machakos and Kitui Districts. Carvers would work at home for weeks, then set out on foot to sell carvings to soldiers and expatriate farmers all over Kenya. Some artists set up stalls in Nairobi and began to sell their wares from there.

There ensued a number of difficulties: peddling was prohibited in Nairobi during the Mau-Mau Emergency in the 1950s; the first Kamba Carving Cooperative met operational difficulties and was obliged to shut down; the Suez Canal was closed, greatly impeding Kamba exports; and the supply of ebony was used up in Machakos District.

But these difficulties did not stem what was becoming an overwhelming flood of orders from abroad. Also, tourists discovered East Africa in huge numbers in the early 1960s and nearly all went away with a Kamba souvenir. At that time much of the paper work and selling of Kamba carvings passed into the hands of Asians living in Kenya who were adept at book-keeping and foreign correspondence. Still, Kamba tribesmen maintained enough direct influence over the trade to keep the profits flowing back to the artists. An artist in any of the large carving centres operative today can earn up to East Africa 50/= shillings a day. The job offers security (often under contract) and a net pay higher than that of many blue-collar jobs.

In Nairobi the largest concentration of Kamba carvers is on Quarry Road in Pumwani District. Here carving sheds may be rented from entrepreneurs who provide wood and will purchase the completed carvings. Nearly all such carving

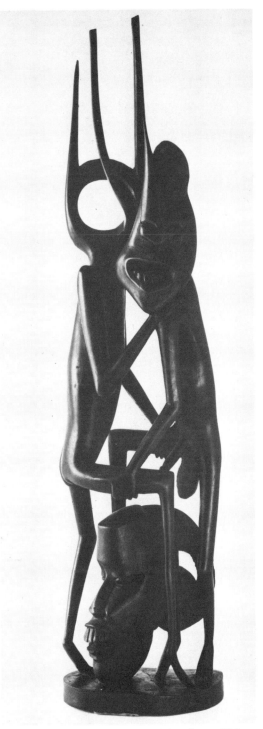

Makonde Carving. Photo Jesper Kirknaes

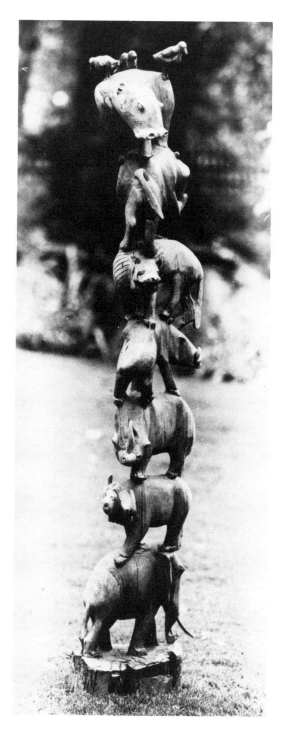

Kamba Totem. Photo David MacDougall

in Mombasa is done at Tudor Creek on the Port Reitz Road at a site rented from the City Council. Carvers pay a 5/= entrance fee to join the co-operative, 5/= a month for rent and are eligible to purchase shares at 20/= apiece. The oldest Kamba carving centre is at Wamunyu in Machakos District, central Kenya, where some 1000 carvers together bring in over 1,500,000/= a month.

At the carving centres labour is divided between wood merchants, carvers and finishers. Wood is usually purchased already cut into 4–15 inch pieces. Carving is done with tools made locally from scrap metal and lumber. Some artists work only on order, but most simply produce as many carvings as possible, hoping to sell them eventually. Carvers who work in assembly-line productions often receive set wages for producing a certain number of carvings per day. The wood used is either rosewood or African blackwood (a type of ebony); some wood is imported from Tanzania. Although the lumber is used up quickly and trees grow slowly, no real difficulties have yet arisen over getting some type of wood, except sometimes during the rainy seasons when roads are impassable.

If wood does become scarce, carvers may go as far as Dar es Salaam in Tanzania to find it. On one such buying expedition a group of Kamba carvers met some Zaramo artists working at the Lutheran Mission at Maneromanga near Dar es Salaam. These were relatives of the Zaramo artists whose works had inspired Mutisia Munge over 40 years earlier. The two groups of artists examined each other's works. Since the Kamba had become so successful, the Zaramo copied some of their designs. Thus, the story goes, the art movement came full circle.

Kamba carvers travel regularly to Zambia, Malawi, The Congo, Zaire and The Sudan, returning periodically to Kenya to carve another load of figurines. A peculiarity of the trade is that artists rarely carve abroad. They prefer to return home for a few weeks' work, then set out again with the produce. The artists seem to need a specific cultural milieu in order to follow the traditions of the art.

Kamba carvings are now sold all over the world

and the market for them continues to increase. New designs continue to be invented for animals, human figures, masks and household items such as salad sets, napkin rings and salt and pepper shakers. Each sculpture has a specifically East African motif, human or animal, calculated to appeal as souvenirs. This and their compact size makes them excellent tourist buys. America supposedly offers the largest overseas market, but shops selling Kamba carvings can also be found in large cities all over the world. In 1965 the leader of the Singapore Trade Mission to Africa asked to import Kamba carvings in Malaysia. In 1967 the African Development Corporation of New York, with Dayton's Department Store and BOAC, organized an African Culture and Arts exhibit in Minneapolis. Kamba art was featured and Kamba artists participated.

Other uses have been found for the carving talent of the Kamba. In Kenya, Enrico Fioravanti hires Kamba artists to copy West African and Congolese art in several media for sales in his curio shops. Such copying often introduces new elements into Kamba art.

Personal fame is not a consideration within the art movement. Only a few individuals have become known by name as a result of association with the Kamba art movement. Gentle Joseph Moko won a two-year grant to study woodcarving in Oberammergau, Germany, in 1967 and then took a teaching job in Bonn. Mutisia Munge's son, Mwambete Mutisia, travelled in Uganda and The Sudan on his way to London, selling and carving figurines. Three Kamba artists spent some years travelling and carving in Europe in the 1960s. They were hired by the German Kaufhof Department Store chain to demonstrate and sell their art. Samuel Wanjau, a Kikuyu who once worked with a Kamba carving cooperative, launched his artistic career by this association. He developed a personal style and has shown his works in several cities in Africa, Israel, Switzerland and Italy. Shem Maluka, a Kamba carver living in Nairobi, has produced many very individual carvings.

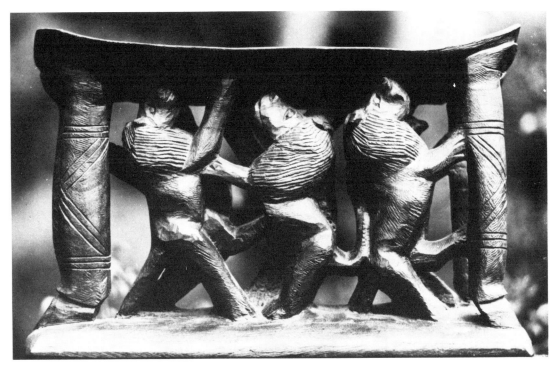

Kamba Stool. Photo David MacDougall

Uniqueness in style is also not a consideration within the movement. But one-of-a-kind carvings have been made by Kamba artists, often under the influence of patrons. They have created eight-foot totems and stools with intertwined animals at the base, a radical departure from the usual modes. Such carvings are the works of genuine underground artists who are kept submerged largely by the restraints imposed by their own highly successful enterprise. A high level of artistic originality is difficult to maintain when one must produce 20 identical carvings in a day. Perhaps one day the public, or a desire by the artists for personal gratification, will demand it.

Kisii Art

In the District of Kisii in western Kenya, hilltop quarries yield a soft, marbled, rose-to-white soapstone which has long been in use locally. Soapstone pots were once used for storing fat, and pipes, bowls, and other domestic items were fashioned from the hand-quarried stone. Face markings of soapstone powder are still applied today for funerals, circumcision rites and festivals. Each village keeps a large stone to be used in preparation for such ceremonies. Sometimes soapstone is bartered with neighbouring tribes in exchange for cattle or other trade.

Around the time of World War I the Kisii began to make figurines out of soapstone. Mzee Moseti Orina, one of the first such artists, has taught carving in Kisii since 1918. Missionaries and a few tourists were the first market for the carvings. Shortly after the Second World War a soapstone carving shop was opened in Kisii town by an Indian entrepreneur. Soon other such shops opened in Kisumu, Kitale, Eldoret, Nakuru and Kericho, and by the late 1950s soapstone carvings could be purchased all over East Africa and in various places overseas.

The first carvings were simple, nearly abstract animals, often copied from book illustrations. More realistic animal figurines appeared next and more recently numbers of useful household items have been added to the repertoire. Such wares

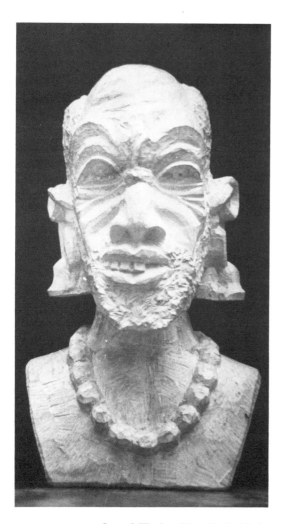

Samuel Wanjau. Photo Daily Nation

as ashtrays, candlesticks, vases and mugs are unadorned, in smooth pearl-pink or blackened soapstone. The animal figurines have a geometric balance, and smooth, usually undetailed, surfaces. Lately carvings of human figures have appeared on the market. Images of pipe smokers or water-bearers are amazingly intricate considering the difficulty of working soapstone in such small sizes (4–5 inches high).

The stone is carved with tools made locally from scrap metal and wood. Carvings are often polished with leaves from the *omosenia*, known colloquially as the "sandpaper tree". The carvings are sometimes baked to turn them black, using a common potter's process: the carving is placed in a wood-burning stove or under a large pot surrounded by flammable grass, wood or charcoal. Stopping the fire suddenly at a high temperature cuts off the air and causes an oxidation process which turns the stone black. Blackening may also be accomplished more simply by applying shoe or floor polish.

In 1964 a Kisii carving cooperative partnership was formed and a soapstone manufacturing factory built with USAID money at Tabaka village, 18 miles from Kisii town. Around fifty artists carve on the premises and a few of these are Company members. But due to various technical difficulties the factory has come to what is hoped is only a temporary standstill. Most of the artists continue to work on the factory grounds.

The partnership is headed by Joel Ombasa Ong'esa, an old name in the Kisii carving industry. His four brothers are partners in the Company and own two of the four main soapstone quarries in Kisii District. Ong'esa's uncle teaches carving at the Prison Industries Workshop in Kisii. He invented the humorous "snake in the box" carving which is a staple Kisii design: as the lid of the box is pulled off a carved snake begins to emerge from within the box; the farther one slides the lid open, the farther out the snake comes, heading straight for the fingers as they hold on to the lid. Younger members of the Ong'esa family have attended Makerere School of Fine Arts and may open a carving school for children in Kisii. Carving is of such general interest in the area children often make figurines as a daily routine. These amateur carvings possess a very special charm and freshness.

Wholesale prices of Kisii carvings are very low and traders can make huge profits by selling at 200–500% above the wholesale price. The artists have received advice from various volunteer agencies as to how to appeal to the tourist market and design carvings that will sell easily.

Enclaves of Kisii artists have appeared all over western Kenya and vendors in the cities are increasing in number. Kisii figurines are still no more than a few inches tall and are made only of soapstone. There is room for expanding the scope of the art in size, design, use and sales. Perhaps the young Kisii artists will help implement an inspired expansion of the art movement.

Makonde Art

The Makonde Plateau, which lies in the District of Cabo Delgado, Mozambique, just south of the Rovuma River and the border of Tanzania, is the original home of the Makonde tribe. Due to the specific geographical characteristics of the area the tribe was somewhat isolated until the military occupation of Mozambique during World War II. Subsequent infiltrations by Catholic missionaries and emigrant Europeans, and border skirmishes between the Frelimo Liberation Front and the Portuguese along the Tanzania border caused a general exodus to the, north. Some Makonde fought with the Frelimo and proved ferocious fighters, re-earning their old nickname, "Mawia" or "the angry people". Over the years those Makonde who migrated to Tanzania have become culturally and linguistically distinct from those still living in Mozambique.

Both groups of Makonde tribesmen have produced such artifacts as boxes and pipes for their own use. The southern Makonde are also known for a distinctive style of face and helmet mask still used in tribal ceremonies. But modern Makonde sculpture was developed by those migrant peoples who now live in southern Tanzania and Dar es Salaam.

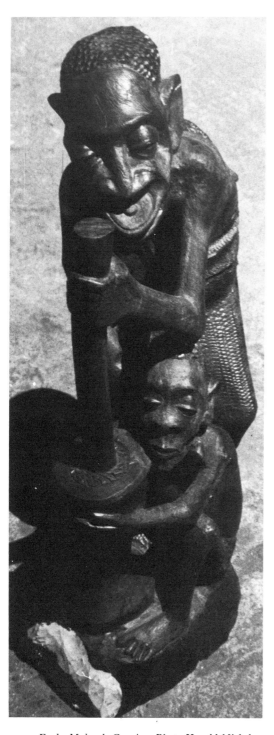

Early Makonde Carving. Photo Harald Nickelsen

Makonde art has gone through an evolution in schematic concepts. Early carvings represented people from everyday tribal life: the drummer, the smoker, the water-bearer, the mother with child. Most of the images were of set design, as with much of traditional African art, and only subtle variety distinguished works of a single design.

An immense stylistic release came with the introduction of *shetani* images to Makonde art forms. *Shetani* are legendary spirits or witches who can help or hinder man according to their whims. *Shetani* can be brutal or serene, sometimes wildly playful, and can take animal, human or monster form. This new type of sculpture freed the artists to express many more personal and involved feelings; often artists created weird creatures from their own dreams. *Shetani* figures are strong on literary content and an artist will usually provide an involved explanation of their meaning. These new sculptures are about twice as tall as the earlier works, measuring some 15–18 inches high. *Shetoni* and early Makonde carvings come in a wide range in quality. Lately the Tanzania Government has begun to monitor prices and to distinguish works of superior quality by higher prices.

A second stylistic innovation in Makonde carvings is the "tree-of-life", consisting of a totem of dozens of interlaced figures rising sometimes to over 4 feet high. The tree-of-life presented new challenges in technique. The figures on the totem can be carved in relief on a solid core of wood or in three dimensions leaving spaces between the figures.

In another departure in Makonde art, modern imagery such as telephones appeared. Artists began to express what was happening about them as well as delving into traditional folklore and dream imagery.

Cooperatives have enabled carvers to bargain collectively and to earn a fairer percentage of the selling price. In 1969, 100 Makonde carvers near Mtwara and Rovuma in southern Tanzania formed the Makonde Carvings Cooperative Society. In 1970 it was affiliated with the Mtwara Co-operatives Union which sold Makonde carvings in eight village buying posts. From the buying posts wholesale buyers take the carvings to Society

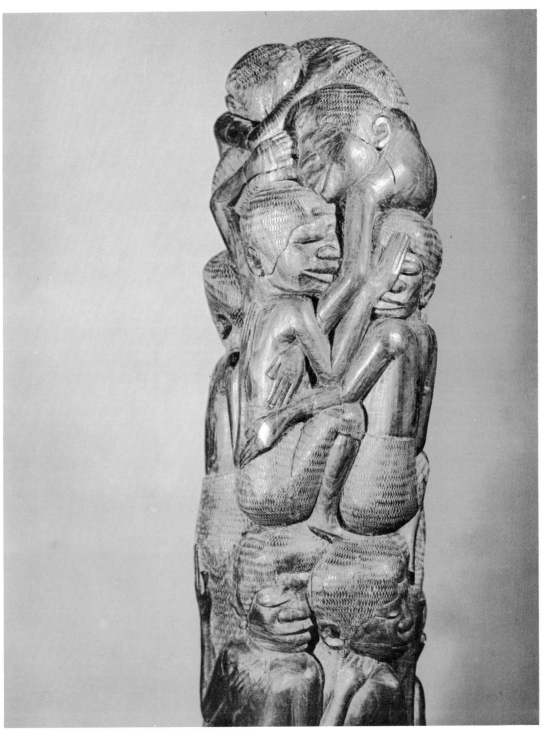

Makonde Tree of Life
Photo Ramesh Shah, courtesy Kenya Shell Ltd

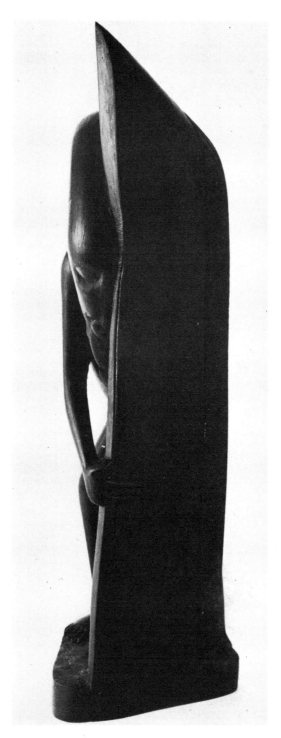

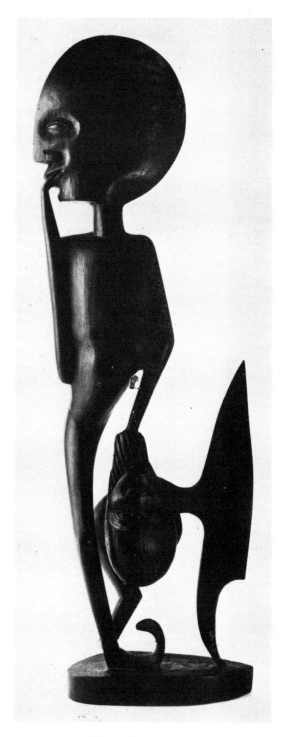

Makonde Carving. Photo Jesper Kirknaes *Makonde Shetani. Photo Jesper Kirknaes*

headquarters in Mtwara where there is a larger buying market. Another cooperative, the Coast Region African Carving Cooperative Society, opened in 1972 and now has over 600 members. Entry fee is 5/=, shares 25/=. Salaried employees do marketing research and carvings are exported to Kenya, Zambia, Australia, Canada, U.S., West Germany and Saudia Arabia. Another 30,000/= worth of carvings is sold monthly to the National Arts of Tanzania.

In 1970 Makonde carvers in Tanzania came under the supervision of the National Development Corporation. They employ several dozen Makonde artists full-time at the National Arts of Tanzania Gallery workshop in Dar es Salaam. Many of these artists once worked for Mohammed Peera, who was for many years owner of the largest outlet store for Makonde carvings in Dar es Salaam. Peera played a large part in the commercial boom of the Makonde art market.

Makonde art has been shown in museums and galleries all over the world. In 1968 Makonde sculpture was exhibited by the Smithsonian Institute at the Anacostia Neighbourhood Museum in Washington, D.C., and 24 works were contributed to Washington's Museum of African Art. In the same year two Makonde exhibits opened in Nairobi, at the New Stanley and Paa-ya-Paa Galleries. In 1970 Makonde artists carved at the Tanzania Pavilion at Expo '70 in Japan. Their popularity netted them some 500 sales a day. In 1971 over 400 Makonde sculptures were shown in Stuttgart, Germany, and thirty works were sent on a two-year tour of the U.S. with the Smithsonian's Travelling Exhibits Department. Gallery Watatu and Paa-ya-Paa in Nairobi also launched major Makonde exhibitions in 1971.

Makonde artists did not until recently begin signing their works, but some carvers have been known by name from the beginning. The earliest of these is Samaki, the artist who introduced the *shetani* mode to the art movement. His works possess a unique inventiveness which sets them apart from the rest, and many Samaki sculptures are in the N.A.T. Gallery's permanent collection. One of the most commercially succcessful artists

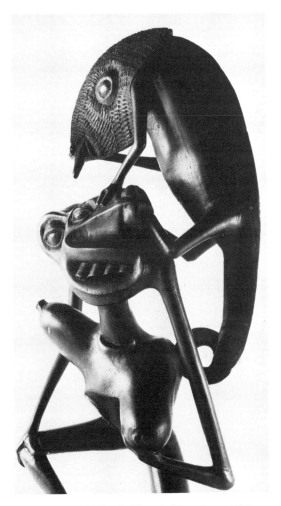

Makonde Shetani. Photo Jesper Kirknaes

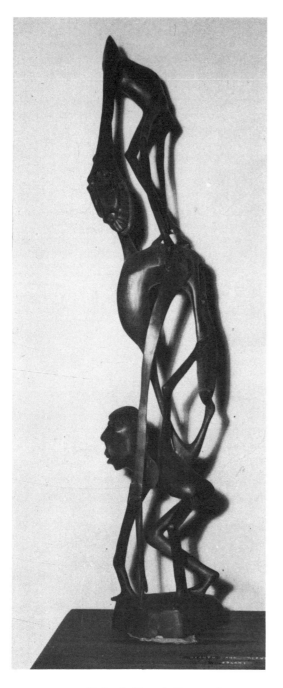

Makonde Shetani. Photo Daily Nation

is Pajuma Alale. He first attracted attention at the Tanzania Pavilion at the International Tourist Fair in Berlin. He went on to London to set up a carving workshop in the East African Airways office; his trip was sponsored by the Tanzania National Tourist Board and East African Airlines. Alale was one of those sent to Expo '70 and has worked with the Tanzania National Development Corporation in standardizing Makonde prices. In 1971 Kiasi Nikitiwie had a sell-out one-man show at Paa-ya-Paa Gallery in Nairobi. Makonde artists Edouard Tingatinga and January Linda exhibited the first Makonde paintings. Tingatinga was famous as a teacher of the art and his untimely death in 1973 was widely mourned.

Many Makonde artists make a living solely by carving. Groups of artists may be found living and working together outside Dar along Morogoro Road, and in Bokko Village. Some find they can earn from 200/= to 4000/= a month. But this is unusual. The artists have had difficulty in gaining much marketing control, but it is hoped that cooperatives and the N.A.T. will help alleviate this problem. The Tanzania Government is well aware of the cultural and economic potential of the Makonde art movement and has given the artists protection and publicity. In an unusual experiment Makonde artists were asked by the Ministry of Health to work at Muhimbili Hospital in Dar es Salaam carving figurines of patients with specific illnesses. The carvings were used in a travelling health programme to help educate rural Tanzanians in the appearance and danger of certain diseases. Makonde artists were also engaged to teach wood carving in Tanzanian prisons.

Much individual and collective talent has emerged within the Makonde art movement and much more is yet to be realised.

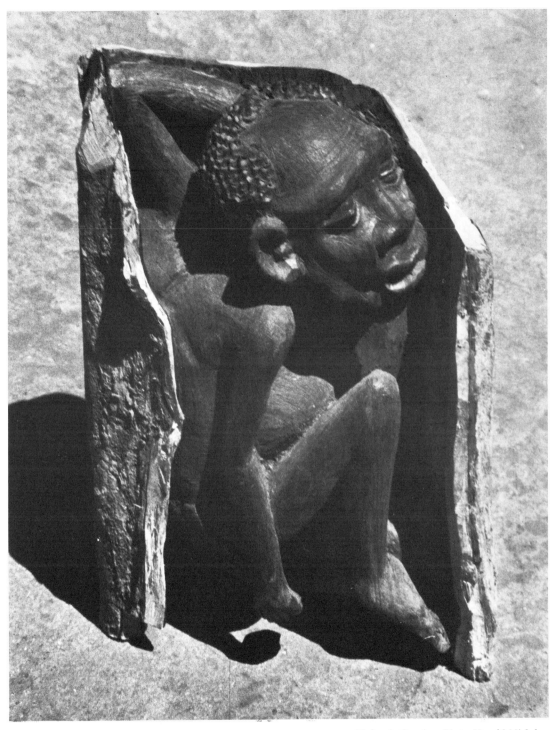

Makonde Carving. Photo Harald Nickelsen

PART III

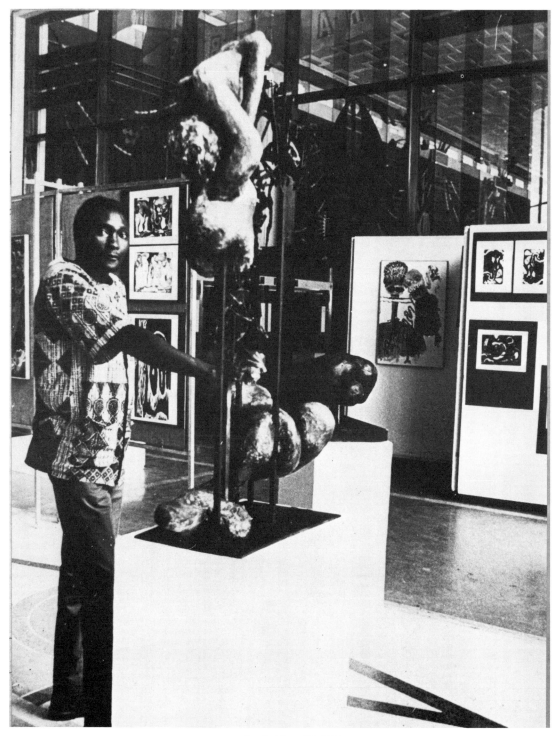

Louis Mwaniki, "Adam and Eve". Nairobi University Exhibition

Art Institutions in East Africa

In addition to recognized artists and art movements the art world in East Africa is composed of dozens of other elements. These include galleries, museums, schools, handicrafts workshops, art societies and art competitions. The low-key activities of each of these generates little publicity beyond a local milieu. Participants in one enterprise may have no knowledge of similar activities in the same district. As there is no catalyst that brings these elements together, and few networks of communication between them, the following sections are an attempt to weave some of the threads into a patterned whole.

Fine Art Galleries

Over the past one-and-a-half decades a handful of art galleries has opened and closed in East Africa. Most of these were located in Nairobi, two in Kampala and one in Dar es Salaam. The earliest were non-profit ventures, some intended as cultural centres offering art classes, seminars and meeting places for artists. The model for these was the Nigerian Mbari Club, a type of art workshop. East African centres, however, although they attracted talented, dedicated people, did not engender the same enthusiastic response as did Mbari. None emerged as viable art centres and most of the early ones have closed. Later galleries have appealed mainly to the commerce of selling art and work with a different set of aims and problems. Today most gallery directors will admit that for every exhibition of quality they must show three of marketability. Unfortunately the categories are not necessarily the same.

Participation in the first East African galleries (early 1960s) was mainly by foreigners. Even today when several galleries are run by Africans the foreign influence has not diminished. Many local artists regard galleries with suspicion because of this and look for non-commercial places to exhibit such as city halls, national museums, private institutions, theatres or centres. Kampala's Nommo Gallery is unique in retaining the support of local Ugandan artists, many of whom played an active part in its inception. Although other galleries are or have been directed by local artists who are well aware of the needs of their colleagues, a community spirit among indigenous artists around galleries is rare.

The needs of African artists fall into two distinct categories. The educated artist with a full-time city job needs a sounding board, public comment on his works and sensitive, competent criticism. He also needs the chance to see the work of colleagues. To such artists an ideal gallery would operate as an extension of his private studio, relieving him of having to show visitors around or discuss prices. His relationship to the gallery would be very personal. He should feel he is showing his work in a manner suited to his personal taste and with other artists he respects. Rural artists have much different work needs. They enjoy a workshop environment where they can be close to colleagues during the creative process. They strive for an integral relationship between their art and village activities. Few commercial galleries have tried to establish this sort of rural

workshop, although directors still discuss the possibility. Several projects exist which provide some assistance to artists at the grass-roots level, but as these involve the creation of saleable handicrafts they are discussed in a later section.

Galleries seem to provide few of the needs of indigenous artists. They are impeded by having to bend to the will of commerce and by other peculiar East African conditions. Most cities in East Africa, for instance, are commercial centres rather than extended villages. They attract those with money and high salaries. Galleries in rural areas are often run by absentee directors and tend to be ineffectual. No one has hit upon just the right formula for an economically successful art gallery which serves the needs of the indigenous artist. The institutions mentioned here have played major roles in tackling these problems. The people involved have shown commendable imagination and perseverance in the face of great odds.

KENYA

The first four galleries have closed and are mentioned for their historical significance

Sorsbie Gallery. In 1960 Sir Philip Hendy, Director of the National Gallery in London, presided at the opening ceremonies of the Sorsbie Gallery. It was housed in the elegant Sorsbie home, a small replica of the Versailles Grand Trianon. Sir Malin and Lady Sorsbie financed the gallery with a grant from their self-endowed Munitalp Foundation. The Foundation was devoted to fostering the arts and sciences in East Africa. Alex P. Mitchell was appointed resident director. In 1963 Tanzanian artist Elimo Njau became assistant director and artist-in-residence. Exhibitions of contemporary and traditional African art were shown. Four times a year exhibits were imported from the British Council in London or the National Gallery of Rhodesia.

As the Sorsbies lived in the exclusive Muthaiga district some distance from Nairobi city centre, patronage even by expatriates was sparse. Only once did they have a crowd-drawing exhibition when 2000 people turned out for an exhibit of new and vintage cars. Since participating artists,

among them Anderson, Fennessy, Kyeyune, Lasz, Maloba and Shepherd, had never been able to draw such crowds, the Sorsbies closed the gallery in 1963.

New Stanley Gallery. The New Stanley Gallery, which opened in 1960, kindled public interest in the arts for a decade in Nairobi under successive directors Val Braun, Pru Paine and Roberta Fonville. Openings became an eagerly-anticipated part of the social scene, frequented in the main by non-indigenous people. Artists took an active interest in the manner and style of exhibitions. Centrally located in the New Stanley Hotel, the gallery alternated exhibitions by contemporary artists with showings of traditional art from the Congo and West Africa. Ten percent of the commission proceeds was donated regularly to the Kenya Arts Society.

The New Stanley Gallery closed in 1970. Over the years many artists had shown their work there, among them Adams, Anderson Fennessy, Kyeyune, Lyimo, Njenga, Rocco and Waite.

Chemchemi Cultural Centre. Perhaps the greatest excitement ever generated by an East African art venture, and the first to be run by Africans, came in 1963 at Chemchemi Cultural Centre in Nairobi. Its chief organizer was the South African writer Ezekiel Mphahlele, at that time Director of the Africa Programme for the Congress for Cultural Freedom.★

Mphahlele became director of Chemchemi and Elimo Njau head of the Visual Arts Programme. Aminu Abdulahi succeeded Mphahlele as director in 1965. Ideas for programmes were given by a group of culture devotees, among them artists Eli Kyeyune and Hezbon Owiti and writers Jonathan Kariara and Hilary Ng'weno. Membership was open to all East African citizens. Workshops, performances, exhibitions, summer seminars

★ The Congress was founded in 1950 to "defend intellectual liberties against all encroachments on the creative and critical spirit of man". It dispensed funds abroad for cultural purposes such as the Mbari Clubs of Nigeria. *Transition* magazine in Uganda was begun with a CCF grant after the 1962 Seminar of African Writers in Kampala.

and symposia were organized for artists, musicians, dramatists and writers. A mimeographed news-letter kept members informed. The Centre's Africana library became an important and well-used public facility.

In 1964 Chemchemi celebrated the opening of its new premises in Nairobi with an exhibition by the Community of East African Artists. Julian Beinard became instructor in the first art workshop. It was attended by 60 people and 200 works were produced for the first exhibition.

Chemchemi lasted for three years. The reasons for its closing are somewhat obscure. The most obvious is that Chemchemi's main donations were stopped. Some say the external funding had deprived members of a sense of autonomy and that the cutting off of funds was a good chance for them to start again alone. It is also clear that such experiments do not succeed as well in Kenya as they do in Nigeria. Differences in their two main cities are a prime reason for this. Thousands of people live in Ibadan, even in the centre. But Nairobi is a business town whose residents live on the fringes and in a series of slums and suburbs some distance from the centre. A cultural centre in Nairobi can only serve those who work in the city or who can afford transportation to its centre.

Julian Beinard became Chemchemi's last director only to supervise closing the premises, dispersing facilities and donating the library books to schools.

Gallery Africa. When the New Stanley Gallery closed in 1970 some of its participating artists had already opened the competitive Gallery Watatu and Gallery Africa. The latter was directed by Mavis Earnshaw and Willard Talkington. Their purpose was to exhibit a wide range of works by

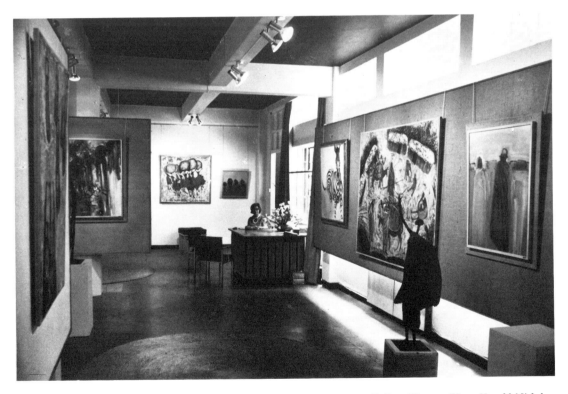

Gallery Watatu. Photo Harald Nickelsen

African artists who had received little attention from other gallery directors. Local artists were energetically solicited and a long list of participants compiled. Included were such known artists as Kyeyune, Msangi and Mwaniki, newcomers Diang'a, Njenga and Njuguna and artists from outside Kenya such as Ugandan painter Katirikawe and Congolese painter Katembo. A new three-level building was the setting for a lively programme of well-publicized exhibitions. Prominent government officials were often asked to preside ˙at opening ceremonies.

In 1970 Gallery Africa, with BBC and the Standard Bank of Nairobi, sent 100 paintings to London for exhibition at Bush House. 220 entries were received from all over the world and three prizes were given: 1000/=, 1500/= and for the winner (Nigerian artist Ugo Egonu) 2000/= and a one-man show at Gallery Africa. All works from the exhibition were sold and 50 were selected for a London tour.

Shortly thereafter Gallery Africa was sold and Gallery Watatu and Paa-ya-Paa became the only similar competitors in Nairobi.

Paa-ya-Paa Gallery. When Chemchemi closed many of the same people* regrouped to start another art centre, this time with local backing and funds. Elimo Njau and his wife, Rebeka, made the largest financial contribution and Njau became manager-director. The name, which translates "The Antelope Rises", alludes to the antelope carvings sold by street vendors from which art in East Africa has risen. Paa-ya-Paa became a sophisticated gathering place for gallery supporters and artists. Friends of the arts met there and Saturday mornings were a particularly busy time. But it became apparent that, once again, art had not been taken to the people. Eventually the supporters withdrew and Njau proceeded alone.

A small snack bar was installed to encourage informal discussions; later it was removed. A

programme of guest entertainers was initiated in 1968: Kenyan writer-poet Okot p'Bitek recited tales; guests danced to live music and drums; Malawian writer David Rubadiri talked about American films; American dramatist-poet-actor Scott Kennedy read from Langston Hughes; informal receptions were held for Dick Gregory and Sidney Poitier; American jazz-poet Ted Joans entertained and Theatre Paa-ya-Paa presented its first play, *The Strong Breed*, by Wole Soyinka. The play was held at the Kenya National Theatre and directed by Jonathan Kariara; Peter Kinyanjui and Elimo and Rebeka Njau took the lead roles.

In 1970 an International Arts Programme was initiated at Paa-ya-Paa with the support of the Presbyterian Church and Crossroads Africa. Njau plans to coordinate the activities of Paa-ya-Paa with Kibo, a rural gallery he owns in Tanzania. The International Arts Programme emphasized the relationship of art to religion. Its first event, sponsored by the Canadian University Service Overseas, featured an outdoor exhibit at Kibo Art Gallery and entertainment by the Tausi Drama Group (who were invited to participate regularly in gallery activities). A new artists' workshop was opened outside Nairobi in 1971. Plans are to build houses and studios for artists and to form a co-operative with artists in Ethiopia and Madagascar.

Paa-ya-Paa regularly organizes exhibitions of the work of local artists, often with opening activities presided over by prominent government officials. Some of the participating artists have been Diang'a, Katarikawe, Musango, Njenga and Wanjau.

Gallery Watatu. In 1969 artists Robin Anderson, David Hart and Jony Waite opened a gallery upstairs from Studio Arts 68 (see Handicrafts Workshops). The two businesses operate with the agreement neither trespasses the other's aesthetic territory. Watatu operates much as a Western-style art gallery and has initiated such activities as luncheon lectures and an art-rental service.

At the grand opening (featuring the work of Anderson and Waite) a painting was raffled and

* Terry Hirst, James Kangwana, Jonathan Kariara, Primila and Charles Lewis, Hilary Ng'weno, Rebeka and Elimo Njau and Pheroze Nowroje.

the proceeds donated to the East African Wild Life Society. Works by university art lecturers Ahmed, Darwish and Kingdon were exhibited together. "Old and Modern Masters in Originals and Prints" borrowed from embassies and private collections attracted unprecedented crowds, as did "Op, Pop and Kinetic Art". Several exhibitions a year are imported, such as "Graphics by Nine Israelis", "The Art of West Africa" and "Japanese Calligraphy". Gallery Watatu has been influential in keeping certain artists' names in the limelight with the result that its participants are often commissioned by hotels and corporations to design art works. Adams, Anderson, Birdsall, Gastellier and Waite have had good commercial success in East Africa, partly through association with Gallery Watatu.

In 1971 the directors of Gallery Watatu undertook a rotating window display in the New Stanley Hotel directly across the street.

East African Wild Life Society Gallery. This gallery opened in 1971 and is housed on the mezzanine of the Nairobi Hilton Hotel. A percentage of sales is given in support of the East African Wild Life Society. Paintings and batiks in wildlife themes are shown along with woodcarvings from The Congo and southern Ethiopia, Makonde carvings and local basketware. An adjacent shop sells guidebooks to the East African game parks and wildlife photographs.

The Tryon Gallery, Ltd. An extension of London's Tryon Gallery opened in Nairobi in 1972. Like its parent body, it specializes in sporting and natural history paintings and sculpture. Under directors The Hon. A. D. Tryon, the Hon. D. E. H. Bingham, Mrs. E. Waddington and The Hon. Patricia Tryon, the gallery exhibits some of the same artists it does in London. Some of these, such as Fennessy, Glen, Kenworthy, Shepherd

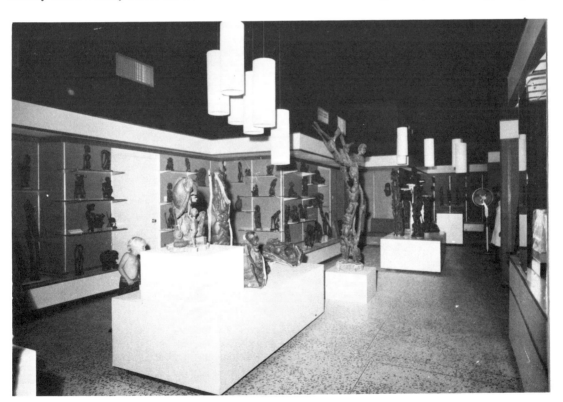

N.A.T. Gallery. Photo Shaancolor Studio

and Thompson, are already well-known in East Africa. Books by the artists are on sale, such as Shepherd's *An Artist's Safari* and Thompson's *An Artist in Africa*. The publications are the joint production of The Tryon Gallery and Collins Press.

Kibo Art Gallery. In 1965 Elimo and Rebeka Njau, now veterans of several East African art activities, financed the building of Kibo Art Gallery. It is located at their family homestead just around the corner from Kibo Hotel at the foot of Mt. Kilimanjaro. Njau felt that, in addition to providing customers, this propinquity would help "bridge the artificial gap between village people and those from sophisticated towns and from abroad". A tented camp was erected adjacent to the gallery for use by artists in living and working on the premises.

The grand opening was a panoply of tribal dances, plays, the Marangu village choir and police band and exhibits by the Community of East African Artists, Makonde woodcarvers and some of the Hans Cory figurines from the National Museum of Tanzania. Shortly thereafter Anthony Stout's *The Art of Makonde* was published under the aegis of Kibo Art Gallery. Four years later Njau helped organize an East African Arts Festival, part of which was held at Kibo Art Gallery.

Njau hoped to attract an *avant garde* among artists and to build a "counter-culture" of underground artists. But the intense interest needed for a counter-culture was difficult to maintain so far from any mainstream of art activity. Still, Njau's enthusiasm never flagged. He described Kibo as,

"... like a mango tree; too slow in growth to compete with ephemeral fashions of the art world; but with roots too deep in the soil to be uprooted by any shallow wind of 'civilization'. Its roots sink deep into the earth to reach out for the bones of our ancestry and the sap that is our heritage from God."

Njau plans to build a theatre on the Kibo grounds and to stage joint exhibitions with his Nairobi gallery, Paa-ya-Paa. Kibo's permanent collection includes works by Kyeyune, Mwaniki, Njau, Ntiro and Wanjau, copies of traditional West African art, local handicrafts and publications by East African artists and writers.

Sanaa Zetu: African Arts of the '70s. The Njaus own a third gallery, in Moshi. Its clientele is mainly local. The emphasis is on handicrafts such as batiks, pottery and jewellery, many of them the work of Rebeka Njau. Situated in the new wing of a downtown building its pleasant surroundings and excellent displays may give Sanaa Zetu the longest life of any of the Njau galleries. Because of its local popularity Njau has nicknamed it "The People's Art Gallery".

Mwariko's Art Gallery. A. Omari Mwariko, a painter and sculptor once apprenticed to Elimo Njau, opened a gallery in Moshi in 1967 to display his own works. The premises were badly damaged by fire in 1971 and Mwariko, the sole staff, made plans to change the gallery's format. It now displays elements from several features of traditional African living: music, clothes, food, animals and even smells!

National Arts of Tanzania Gallery. Although Dar es Salaam is the home of several art societies and cultural organizations, it had no art gallery until 1970. In that year the Government-supported National Arts of Tanzania opened its own gallery. N.A.T. is a subsidiary of the Small Industries Development Corporation under the aegis of the National Development Corporation of Tanzania. Its purpose is to purchase, display and sell the art of Tanzania. The gallery employs 75 full-time Makonde artists at its workshop in Changombe, a suburb of Dar es Salaam. N.A.T. also runs the Tausi Handicrafts Shop in Dar es Salaam and another gallery in Arusha. All overseas exhibitions and purchases are administered under Acting General Manager E. S. Challe. The gallery in Dar es Salaam is run by Mrs. Gil Helleberg.

Exhibitions are sent all over the world and 80% of the carvings are exported, to the U.S., France, Japan, West Germany and Scandinavia. N.A.T. retains a 25% commission from the selling price; the rest goes to the artists.

At Expo '70 in Japan Makonde artists from N.A.T. made carvings with a crowd-drawing appeal that netted them some 50,000 sales. In 1971 an exhibition was sent to Gallery Watatu in Nairobi and a travelling exhibition of 30 sculptures and 40 artists was sent to the Smithsonian Institution for a U.S. tour. N.A.T. exhibited at the Commonwealth Institute in London in 1973 and other travelling exhibitions are being planned.

N.A.T.'s primary aim is to prevent the exploitation of Tanzanian artists and to see that artists receive a fair percentage of sales prices. N.A.T. also hopes to set standards for Makonde art and has instituted a "stamp of approval" for sculpture they sell. The National Arts of Tanzania brings in some 2,000,000/= in foreign exchange each year. It has encouraged the Tanzanian Tourist Corporation to buy woodcarvings to decorate its lodges and hotels. It has also established collection centres and finishing workshops in Dar es Salaam and Mtwara. Carvers are provided raw materials, tools and workspace and can acquire shares in N.A.T. through local cooperatives. Incorporated in 1970, N.A.T. now employs a staff of thirty.

The prospect of government control of art projects elicits varying responses from artists. Some are automatically apprehensive of having anything to do with governments. Others merely prefer to work on their own without outside intervention, government or otherwise. But some artists welcome the chance to reap the benefits N.A.T. proposes to ensure. It is still too early to tell what effect the National Arts of Tanzania will have on the quality of Makonde art. Major artists working

Makerere Art Gallery

with N.A.T. are Pajuma Alale, Anesta Chibanga, Clemente, Destani, Hatesi, Tomas Mtundu and Edoarde Nangundu.

UGANDA

Makerere Art Gallery. This non-commercial gallery houses East Africa's first and finest permanent collection of indigenous contemporary art. The works are not for sale. Paintings and sculpture by outstanding students and faculty at Makerere School of Fine Arts have been collected for the gallery since 1940. The collection was begun by Margaret Trowell, founder of the art school. As three-fourths of the practising artists in East Africa have studied or taught at Makerere, the gallery's collection is uniquely comprehensive. The building was designed by Nairobi architect Richard I. Hughes. In excellent use of space and aesthetic appeal the building does much to en-

hance the collection. The building was erected in 1968 with funds from the Calouste Gulbenkian Foundation, London, and is located on the Makerere Art School compound.

Nommo Gallery. In Kampala the sole commercial art gallery has been supported by most of the artists in the area. Founded in 1965 as a non-profit trust, Nommo has a predominantly Ugandan board of trustees. Mrs. Miria Obote, wife of the then President of Uganda, headed the first funds appeal committee. Financial support came originally from private persons in Kampala and England (among them Sir Andrew Cohen, former Governor of Uganda) and the Farfield Foundation, New York.

A community of artists had existed in Kampala for many years, attracted in part by the Makerere School of Fine Arts. These artists needed a place to exhibit and sell their works; some served on

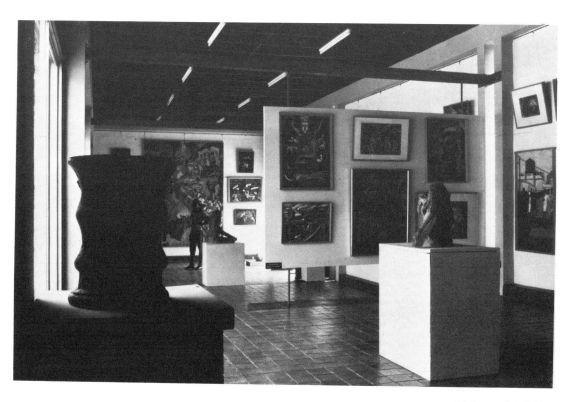

Makerere Art Gallery

Nommo's executive committee. Nommo elicited a great deal of support and interest from the Kampala community and from the Uganda Government. Cabinet ministers often opened exhibitions. In 1968 a National Party Conference on the Arts moved that President Obote donate the guest house of his lodge on Nakasero Hill, Kampala, to Nommo Gallery. This increased the gallery's space threefold. The new grounds were used for poetry readings and play rehearsals by several groups in Kampala. An exhibition was held there during Pope Paul's visit to Uganda in 1970. But Nommo's shoestring budget and skeleton staff had difficulty managing these new activities. The gallery closed for several months in 1970–71 and reopened under new directorship. General Idi Amin Dada, the new President of Uganda, presided at Nommo's second opening exhibition. The President's own art collection includes several works purchased from Nommo.

Nommo Gallery has no competitors in Kampala, but still has difficulty contending with the conflict between being selective and making money. Tourists comprise its greatest market and the local demand for art is small. A series of quasi-volunteer directors has dealt admirably with Nommo's potential: Barbara Brown (Mrs. Rajat Neogy), Lesley Nelson, Sidney Kasfir, Nelson Kasfir, Mindy Mottram, Adelina Lubogo and Trudi Knapman (sister of artist Therese Musoke). Notable exhibitions at Nommo have been "Makonde Carvings", "Islamic Decorative Arts of the East African Coast" and the annual Uganda school art exhibitions.

Museums

East Africa's three national museums have been recipients of the most valuable ethnographic and archaeological research finds in the area. In the late 1920s Hans Cory began to collect, investigate and write about the clay figurines made by tribes in Tanzania. In 1943 he was appointed Sociologist to the Government of Tanganyika. In a series of reports and several books he docu-

mented the use of the figurines by local tribes in educating children to social mores and tribal customs. The Hans Cory Papers are on file in the University library in Dar es Salaam; the figurines themselves are in the Tanzania National Museum. In Uganda, Margaret Trowell's several books and papers on East African arts and crafts are testimony to her intensive research from 1930 to 1950. She contributed greatly to a well-documented collection of Ugandan arts and crafts and its organization and display in the Uganda Museum. The archaeological finds of Neville Chittick, James Kirkman and the Louis B. Leakey family are in the Tanzania and Kenya National Museums. Jean Brown conducted a systematic search for ethnic artifacts from every tribe in Kenya. Many of these are now on view in the Kenya National Museum. James d. V. Allen collected, catalogued and wrote about the culture of Lamu for the new Lamu Museum. The Western Kenya Museum houses the natural history collection of the late Lieut.-Col. H. F. Stoneham. In Tanzania the staff of the Sukuma Museum, under the direction of Fr. David Clement, conducts research into and promotes Sukuma culture.

These undertakings, among the most scholarly and ambitious in East Africa, have been carried out by dedicated individuals. Many have or will spend their entire lives on these projects. The museums which display their finds are exemplary institutions which also involve themselves in extensive education programmes for the people of East Africa.

KENYA

The National Museum of Kenya. In 1909 a group of eminent Kenya settlers* with avocations as naturalists founded the East Africa and Uganda Natural History Society. Its aim was to promote the study of all branches of science. In 1910 Kenya's first museum was built to the Society's

* H. H. F. J. Jackson, R. J. Cunningham, L. J. Tarlton, The Hon. A. C. MacDonald, J. Sergeant, Dr. A. D. Milne, E. Battescombe, T. J. Anderson, Dr. C. A. Wiggins, C. W. Hobley, Lord Delamere.

specifications; the small two-roomed building still stands near the Nairobi Central Police Station. In 1918 funds were raised for a new and larger museum which opened in 1923. This building was designated by the City Council as a national monument.* In 1929 the present building was erected as a memorial to Sir Robert Coryndon, once Governor of the Colony of Kenya. The Society was invited to transfer its exhibits and headquarters there, and the Kenya Government took over the old building. With money paid by the government in compensation, workrooms were built at the back of the new Coryndon Museum. The East Africa and Uganda Natural History Society organized and maintained museum services there from 1929–39. At this time a government ordinance set up a Board of Museum's Trustees of Kenya and control of the Coryndon Museum was passed to it. The Society was paid 2000/= for fifteen years ($\frac{1}{10}$ of the total assets) in return for handing over all Museum assets to the new board. The Society retains free use of the Museum and access to workrooms and study collections. Two Society members are on the board of trustees, and the Society's library is housed in the Museum.

Dr. V. G. K. Van Someren was Director of the Coryndon Museum until Dr. L. S. B. Leakey took over in 1939. Leakey was succeeded in 1961 by Robert H. P. Carcasson and Richard Leakey became Director in 1968. In 1964 the Museum's name was changed to The National Museum of Kenya.

Today the research staff of the Museum includes a mammologist, herpetologist, ornithologist, entomologist, archaeologist and several paleontologists and zoologists. In addition there are also departmental curators who do not engage in research. The most complete research collections are of birds, butterflies, moths and amphibians, representing specimens from all parts of Africa (although specializing in East Africa).

The Museum's prehistory gallery has been redesigned and the ethnographic displays in the Hall of Man and those on geology, ornithology

* It is located opposite St. Andrews Church on Kenyatta Avenue.

and botany are being reorganized. Money was allocated by the Kenya Government for a new wing to house a hall of conservation and a hall of mammals. Work began on the new building in 1972.

Associated with the Museum are the Centre for Prehistory and Paleontology founded by Dr. L. S. B. Leakey in 1962, the Snake Park and the Education Section. The latter coordinates its programme most closely with the Museum. It originated in 1963 with a Ford Foundation grant to make museum facilities available to schools. In 1968 the programme was increased to include lectures and films and in 1969 a seminar for the Wild Life Clubs of Kenya was organized. This is now self-managing. The most important aspect of the work of the Education Section is its regular programme of school visits to the Museum. A wide assortment of slides, films and informative pamphlets is available and delivered on request to teachers. The staff also gives courses in biology techniques and conservation at Kenyatta College and the Kenya Science Teachers College.

The Institute of African Studies of the University of Nairobi operates two programmes in conjunction with and on the grounds of The National Museum of Kenya: the National Archaeological Survey and Salvage Project and the Kenya Material Culture Project.

Several ancient monuments, museums and archaeological sites also come under the Museum's auspices. In 1969 Fort Jesus in Mombasa and the ruins of the ancient coastal city of Gedi became a part of The National Museum of Kenya. Both of these monuments were excavated and maintained by Dr. James Kirkman. Also in 1969 three archaeological sites came under Museum auspices: Olorgesailie, Hyrax Hill and Kariandusi. In 1970 the Lamu Museum opened under Museum auspices. Its collection comprises artifacts from the Lamu archipelago collected initially under the supervision of its first curator, James d. V. Allen. In 1972 the Western Kenya Museum was included under the aegis of The National Museum of Kenya. It houses the natural science collection once kept in the Stoneham Museum. The new

building was provided for in the will of the late Lieut.-Col. H. F. Stoneham, who made the collection; the building was designed by Nairobi architect Derrick Flatt.

The National Museum of Kenya in Nairobi is open from 9.30 to 6.00 every day. Volunteer guides offer a multi-language tour service. Admission is 5/= for non-residents, 2/= for Kenya residents.

National Museum of Tanzania. In 1899, under the German Colonial Government in Dar es Salaam, a small collection of mainly geological material was begun. It was lost during World War I when the building in which it was housed was used as a military headquarters. In 1934 Harold MacMichael, British Governor of Tanganyika, initiated the collecting of ethnographic, archaeological, historical and artistic material by district officers and others able to do field work. These items were stored in the Sajid Barghash Building, one of the oldest in Dar es Salaam. The collection was organized for public view there in 1937. After the death of King George V a memorial fund, matched by the British Government in Tanganyika, was used to erect a new museum building. Captain Boys Hinderer designed the building on the site of the botanical gardens. World War II delayed its opening until 1940. Mrs. E. Gillman became Temporary Curator and Secretary, and Graham Hunter was appointed first Scientific Curator in 1949 of a collection of around 600 items. Donations, contributions from District Officers and special finds increased the collection over the next eleven years. During that time Joan M. Harding succeeded as Curator.

In 1960 Curator Stanley E. West oversaw the reorganization of the now National Museum of Tanzania and planning for a new building by architects French & Hastings. The building was erected in front of the old one in 1962–63. Later, store and office space were increased and room added for an Antiquities Department. A third

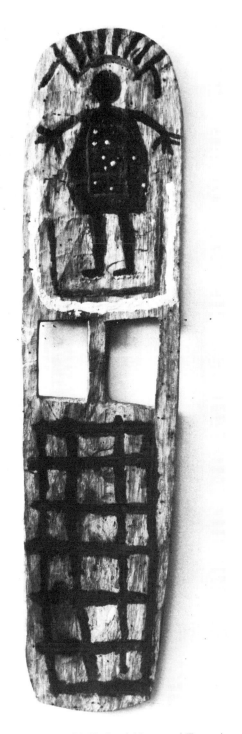

Sandawe Ritual Shield. National Museum of Tanzania

49

building phase added to the display and library facilities and Technical Department workrooms and included a lecture hall. Grants for the extension work came from the Tanzania Government, Gailey and Roberts, Diamond Corporation (T) Ltd., Ford Foundation and the East Africa Tobacco Company.

The National Museum of Tanzania is now a parastatal institution headed by a board of trustees appointed by the Minister of National Education and a specially appointed chairman. A management committee selected by the board deals with policy, staffing and management.

Curator P. Carter (1965–67) was succeeded by Richard Meyer-Heiselberg on a bilateral agreement between Tanzania and Denmark. In 1966 the Village Museum was opened eight kilometres north of Dar es Salaam along Morogoro Road. Life-sized houses representing several ethnic groups in Tanzania were constructed as authentically as possible by people used to living in them. Some materials had to be specially transported. Simulated village activities and dances are held in this open-air museum; Makonde and Zaramo artists work on the premises. Also on the grounds are a shop, a crafts demonstration area and a restaurant which serves African dishes. An excellent booklet published by the National Museum of Tanzania describes in detail the methods of housebuilding shown at the Village Museum. Financial aid came chiefly from the Tanzania Tourist Board and other small grantees, among them the University of Dar es Salaam.

In 1969 UNESCO donated a mobile van which was fitted with ethnographic displays. An Education Officer now tours the rural areas, schools and other institutions with the mobile museum. Further expansion of the Education Section will include another Education Officer in charge of the internal service. This section already has a substantial collection of visual aids, books and tape recordings. Negotiations in 1970 created the framework for future regional museums to expand the National Museum's scope and audience.

The display system at the National Museum of Tanzania has been completely modernized. It now includes a Temporary Exhibitions Hall reserved for items from its storage rooms, Tanzanian arts and crafts and contemporary exhibitions from Tanzania and abroad. In the Hall of Man the anthropological section displays the Zinjanthropus skull given to the Tanzania Government in 1965 by Dr. L. S. B. and Mrs. Leakey six years after it was found in Olduvai Gorge. A special section in the History Gallery exhibits materials from the ancient coastal city of Kilwa excavated by Neville Chittick. The old building houses a specialized library, workshops and permanent ethnographic and topographical sections. A rotated exhibition there features the clay figurines collected by Hans Cory.

The National Museum of Tanzania intends to raise funds for publications and is already reproducing staff articles in its Annual Reports. Entry to the Museum is free, daily from 9.30–7.00, Sundays 2.00–7.00. A shop sells Tanzanian arts and crafts. Yearly attendance is now over 100,000, of which 60,000 are Tanzanians.

The Sukuma Museum. Missionaries have a bad record as regards preserving indigenous cultures, but the work of the White Fathers in Tanzania shall certainly be an expiation. Since 1955 they have engaged in research into the culture of the Sukuma, the largest tribe in Tanzania. The Sukuma Museum, which is far more than a museum, shows the fruits of these efforts.

In 1955 Fr. David Clement of the White Fathers Mission founded the Association of St. Cecilia to work on incorporating Sukuma culture into the Catholic liturgy. Through expansions of their efforts the Sukuma Museum was founded and a widening programme of activities initiated. The Church of Bujora was designed by Fr. Clement under the guidance of the Most Rev. Bishop J. Blomjous. It is in the style of a Sukuma house, decorated and furnished with ethnic utensils and ornaments. Fr. Clement directed the construction and local donors paid for most of the expenses. The roof was financed by Canadians. Services are held in the Swahili and Sukuma languages; Sukuma folklore and music play an integral part in the Catholic ceremony.

In 1968 the Sukuma Museum was opened in Mwanza. It is shaped like a Sukuma royal throne. On the flat top an open hut houses ancient royal drums. Inside are thrones, domestic utensils, beads, badges and other items used by chiefs and leaders of the Sukuma. The insignia of the late Edward Mbilingi, King of Sukuma, once passed down from generation to generation, now hangs on a wall of the Museum. The building is on the site of a former chief's headquarters. Two mammoth huts supplement the Museum, displaying bows and arrows, shields, spears, bird nets, handicrafts and various objects of witch-doctoring. In the courtyard are 350 varieties of Sukumaland plants, many of them once used by medicinemen. Copies of the pebble game board, *isolo*, (or *bau*) once the royal game of Sukuma chiefs, are sold at the shop. Three huts for blacksmiths stand near the Museum, built with donations by the U-Landsfonden of Arhus, Denmark. This corporation sells Sukuma handicrafts in Denmark and returns the profits to the Museum. Every year the Museum sponsors an exhibition of the melting of iron ore and fabrication of spears, arrows, hoes, axes, etc., by Balongo blacksmiths who traditionally performed this service for Sukuma chiefs.

Recently another building was added to the Museum compound—the Bagalu Bagika Hall—built especially for Sukuma dancing. Here prominent Sukuma religious dance leaders display their amulets, ceremonial dresses and other sacred belongings. The Sukuma Dance Troupe has become known all over Tanzania on its tours of the National Game Park lodges. They have performed the ancient royal dance several times for Tanzanian President Julius Nyerere. The Bagalu Bagika Hall is of Canadian design and was financed by the Dartington Africa Trust of England and a personal donation from President Nyerere.

The missionaries in Mwanza have a staff engaged in research into the natural history, culture and political history of Sukumaland. A library of Sukuma literature, songs, poems and legends is

Sukuma Royal Museum,
Royal Pavilion and Dance Pavilion

51

being developed. The latest addition is a school of Sukuma handicrafts—ironmongery, basketry, pottery and carving.

The Tanzania Government sees the work at the Sukuma Museum in line with its own plans for preserving the national culture, and has supported the development of activities in Mwanza. Hundreds of people visit the Sukuma Museum daily, hours 8.00–6.00. Entry is free.

UGANDA

Park Museums of Uganda. In 1959, at the request of the Uganda National Parks, three museum cases were prepared in Queen Elizabeth Park which showed visitors the geological and cultural succession of fossil and archaeological finds in the park. From this the Park Museums of Uganda developed, one in each national park in Uganda.

Teso Museum. The Teso Museum emerged as an offshoot of the Teso Museum Society, founded in 1958 by the Makerere University Extra-Mural Department. It contains fossils and other geological and ethnographic materials.

Uganda Museum. Collecting for a Uganda Museum was begun in 1901, but the ethnographic material gathered then by District Commissioners was lost. In 1908 a museum was officially established under the Botanical, Forestry and Scientific Department of the Uganda Government. Donations of £200 were given by the United Kingdom and the Chiefs of Buganda. A small building in the style of a Greek temple was erected and still stands at the Old Kampala Fort. For thirty years management of the museum was transferred from one government department to another. The museum had little popularity with the indigenous population who looked upon it as a "house of fetishes"

Sukuma Royal Museum, Blacksmith's Pavilion

created to give strength to the colonial government. Margaret Trowell became its director in 1941. That year a local teacher was arrested and put into an insane asylum for taking too great an interest in the collection of witchcraft objects. Mrs. Trowell's husband, who was in charge of the insane asylum, had the teacher released. Mrs. Trowell had the task of erasing this strong prejudice from the minds of local people. She organized and catalogued the unwieldy collection and saw that it was presented in new ways. The museum was moved to the Makerere University campus, a constitution drawn up and a guaranteed annual income provided by the colonial government and the King George V Fund. When Mrs. Trowell left the museum in 1945 attendance had risen to 10,000 a year.

After three interim directors, Dr. Klaus Wachsmann became curator in 1948. He began a collection of musical instruments which was to become the most complete in Africa. Attendance rose still further and the collection was increased. The American Museum of Natural History sponsored a film about African music in which the museum's musicians appeared.

The Uganda Museum left its Makerere premises in 1952. All contents were put into storage for two years while construction took place on a new building made possible by a government grant. The building has a central hall for temporary exhibits, a main hall depicting the history of man in Uganda from the Stone Age to the present and a music gallery. A fish pond was filled in to allow more floor space. An upper storey contains offices, a library and a music room; storage space, workshops, a mounting room, dark room and laboratory are in the basement.

In 1955 delegates from East and Central Africa and Ghana met in Kampala at a conference of museum curators to form a Museum Association of Middle Africa. Its aims were to provide training in Africa for museum assistants, prepare films on African tribal life and exchange exhibitions and personnel between African museums. Unfortunately the Congo crisis prevented the first meeting being held. The idea of an African Museum Association may still be revived and these ideas brought to fruition.

When Dr. Wachsmann retired in 1956 Mrs. Trowell replaced him until the arrival of Dr. Merrick Poznansky in 1958. The museum then had 53,000 visitors a year, 73% African, 17% Asian and 10% European. Dr. Posnansky set up the contemporary exhibits hall. Twelve to twenty-four presentations of contemporary art are held there each year. The museum takes a 15% commission on any works sold, but artists may exhibit free of charge.

The Museum's collection is increased in several ways. Memorabilia have been donated by private persons, including Alan Morehead, who gave some original Gordon documents. Professional collectors are asked to help fill specific ethnographic gaps. Excavations in several parts of Uganda have uncovered some dimple-based pottery from one of the first Iron Age pottery cultures in East Africa. The pottery is now on view in the Uganda Museum.

Dr. W. W. Bishop succeeded as curator in 1962 when the Museum was transferred from the Ministry of Education to the Ministry of Information, Broadcasting and Tourism. Charles Sekintu, the Museum's artist-technician for twelve years, was appointed trainee curator and sent to the United States to study museology. Mordecai Buluma became Education Officer in charge of a country-wide Mobile Education Service. Ford Foundation contributed funds for an education building and a natural history centre. In 1965 Sekintu became the first African curator of the Uganda Museum, the second such post to be held by an African on the entire continent. By 1966 the government increased its grant and raised Museum salaries to a level commensurate with civil service salaries.

Extensions are being made for better storage and more exhibition space. Musicians (who double as guards) perform for visitors on request and allow guests to inspect the musical instruments. Dancers perform at various times during the week. On Sundays visitors may participate in Acholi tribal dancing. A dance instructor and two music

teachers are on the staff; they also teach in nearby schools and colleges. The Makerere University music tutor holds classes at the Museum. Admission is free.

Handicraft Workshops

The production by local people of crafts for public sale is a fairly recent, fast-growing, phenomenon in East Africa and has great commercial potential. The principal aims of those involved have been to preserve and encourage indigenous methods of making handicrafts, to create jobs for local people or to exploit the huge East African tourist market. The three East African countries participate in different ways.

In Kenya, authentic, used, tribal artifacts may be found for sale in the National Museum or in numerous crafts shops. Such items, collected by entrepreneurs, researchers or interested persons, may be difficult to find and are often very expensive. It is easier to buy traditional tribal artifacts which, although authentic, were made to be sold and have never been used. The Masai, for instance, have outlet shops for their bead work, calabashes, spears and snuff boxes, most of them made especially for sale and not for local use. Selected items from the Swahili culture, such as wooden chests once used by sailors, are now made from new materials.

By far the greatest commercial crafts business in Kenya is in the redesigning of traditional artifacts for modern use and special appeal to tourists. Dozens of such workshops exist and their sponsors may be governments, churches, businesses or private persons. Shops all over Kenya specialize in sales of these products. That the handicrafts are no longer truly authentic is no deterrent to sales. In fact, redesigned artifacts are more popular, perhaps because they are more useful or more hygienic (to city buyers), than are the original, used models.

In Tanzania fewer crafts shops exist than in Kenya and the greatest commercial art trade is in the carved statuettes discussed in Part II. The National Arts of Tanzania initiated a pilot scheme in 1972 to do a countrywide survey of existing handicrafts. With the help of Regional and District Development Directors a list was compiled of institutions and individuals engaged in the production of handicrafts. Commercial links and suppliers, cooperatives and voluntary institutes were created or encouraged to participate in organizing artists in factory-type production centres where functional specialization would be introduced. Some of the proposals were to create buying centres and handicrafts villages, to stock raw materials, to improve tools and provide warehousing and showrooms at tourist centres. A National Handicrafts of Tanzania five-year plan was proposed.

The Tanzania Government has held several conferences discussing a proposed national organization of all culture, from tribal dances, songs and literature to art works. In 1971 at a conference on "Concept and Philosophy of Tanzanian Culture" it was suggested all traditional ceremonies and songs henceforth be performed only in Kiswahili, to discourage tribalism in the use of tribal languages. It was also put forth that African culture should be emancipated by stopping its imitation of foreign cultures and that revolutionary poetry and songs be encouraged to inspire nationalism. At another conference that year delegates discussed how to maintain Tanzanian culture in "Ujamaa" ("for the common good") villages. In September 1971 UNESCO and the Tanzania Government co-sponsored a conference on colonialism and art. Topics included the role of artists, social commitment and great art, the quest for a national identity, integration, and development and the committed artist. Participants (20 artists, historians and sociologists from America, Europe and several countries in Africa and Asia) agreed Tanzanian culture should deal with the economic revolution and become involved in the African liberation struggle.

TANU, the Tanzanian national political party, was involved in the formation in 1974 of a Ministry of National Culture and Sports. TANU is concerned with village-level culture within

socialist values and practices and the role of culture in economic revolution. Through the new Ministry, the party promotes participation in cultural activities and seeks to eradicate traditional customs which hinder national progress. The Ministry of National Culture and Sports, under Major General Sarakikya, will promote the creation of new songs, dances and instruments and put a ban on the commercialization of culture. It has appointed 70 District Cultural Officers to help preserve and collect ethnic artifacts. The Ministry deals only with correspondence in Kiswahili.

In Uganda the crafts offered for public sale seem the most authentic of any in the three East African countries. Few foreign-run crafts enterprises or redesigning operations exist and the government is involved only to provide a service, not to influence.

The Uganda Government runs markets in Kampala which sell artifacts collected systematically from tribes all over Uganda. An illustrated pamphlet indicates a few items designed "for modern use", but shows that most have not been altered from their original design. Profits go back to the artisans for dozens of products such as Ankole milk jugs, Karamojong bead aprons and Tusi coiled baskets. The government has also given book-keeping instruction and monetary grants to individuals wanting to set up private crafts enterprises.

Of the three countries, Kenya does the most lucrative commercial business in crafts production. But Uganda has brought to public view many more authentic, traditional designs and encouraged continuation of their creation. Tanzania has branched into new territory in considering the relationship of the artist to the State. The following enterprises have come to exist under three very different approaches to the contemporary use and creation of traditional handicrafts.

KENYA

African Heritage Ltd., opened in 1973 under directors Joseph and Sheila Murumbi, Alfredo Santigatti and Alan Donovan. The shop commissions contemporary painting and sculpture, jewellery, clothing, leather goods, rugs and tapestries from African artists. It also buys traditional art from all parts of Africa and sells musical instruments, ethnic artifacts, photographs, cards and historical books and manuscripts on African subjects. The comprehensive selection is beautifully displayed. African Heritage Ltd. has plans to provide workshop facilities for artists and to arrange travelling exhibitions.

Bomas of Kenya, Ltd., is a government-backed company formed in 1971 to build cultural centres. *Boma* is a Kiswahili word meaning fortification, or a complex of government buildings. The first of these cultural *bomas* was built just outside Nairobi near the main entrance to the Nairobi Game Park. It includes a group of traditional tribal houses in which artisans can make ethnic artifacts. The main building is a large, circular, cone-roofed hall where dances and other entertainments are held. Housing is provided on the premises for performers. Souvenir shops, a restaurant and a lake stocked with fish complete the facilities.

Other such cultural *bomas* are envisioned for Mombasa and other tourist centres in Kenya. It is hoped they will prevent "unscrupulous commercialization of Kenya's cultural life".

Cottage Crafts. The National Christian Council of Kenya organizes workshops, groups, cooperatives and individuals all over Kenya to produce traditional handicrafts. The NCCK provides the central organization needed to encourage production, improve quality and design, market the articles and see to it the artisans receive fair payment for their work. The Cottage Crafts shop in Nairobi sells basketry, jewellery, pottery, garments, cloth, woodcrafts, lampshades, leather crafts, sisal work, chairs, toys, banana fibre work and books by African authors. Designs are both traditional and modern.

Home Industries Centre. In 1964 the NCCK initiated a self-help programme for women in Mombasa. Its first five years were financed by British Inter-Church Aid, the Anglican Church of Canada, the Lutheran World Federation (Sweden) and Bread for the World (Germany). The programme operates as the Home Industries Centre and consists of a retail shop and a workroom. Sisal, beads, leather, cloth and other raw materials are provided for workers at minimum prices. Handicrafts are made at home and brought to the shop for sale. The shop adds a 25% commission to its selling price. Items for bulk sales to retailers may be selected from a twelve-page catalogue complete with photographs. Prices at the Home Industries Centre are among the most reasonable in Kenya for handicrafts such as tie-dyed cloth, batik prints, tableware, sandals, wooden stools, decorated calabashes, stone carvings, jewellery, musical instruments, mats, baskets, toys, beadwork and earthenware pots.

Two groups operate within the centre. Women with traditional handicraft skills are given advice on how to widen the range of articles they make and how to adapt designs to meet consumer requirements. Workers may send their produce to the shop from anywhere in Kenya. Some articles come from as far as Kisumu on the Uganda border from an estimated 700 women. Ten Mombasa women participate in the dressmaking workshop. They are provided a workroom, cloth and sewing machines and can earn from 200/= to 300/= a month on piecemeal payments. One member is being trained to take over leadership from the foreign volunteer and the group will eventually become self-supporting. The workshop makes dresses, shirts, ties, beach wraps, trouser suits, ponchos and hats and can do made-to-order work on short notice. Fashion shows are held in local hotels during high tourist seasons.

Mrs. Elvina Mutua, who replaced the Home Industries Centre's foreign director in 1968, works with a staff of four Kenyans. Several foreign volunteers contribute design ideas to workers. The

Home Industries Centre

shop is similar to that of Maendeleo ya Wanawake in Nairobi and the two enterprises refer women to each other.

The Centre is just off Mombasa's main tourist shopping street and has few similar competitors in the area. The attractively decorated shop and pleasant salesgirls help to ensure the continuation of this worthwhile business.

Karibu Gallery. Opened by Shariff Mohamed in 1971 the gallery specializes in making new chests or remaking old ones, refinishing antiques and designing textiles. Its gift shop also sells Kamba, Makonde and Kisii sculptures, baskets, copperware and paintings. The shop is located near the big mosque in Mombasa.

Khanga, Kikoy and Kitenge. African women have been wearing bright printed cloth in distinctive "African" patterns since they discarded barkcloth and skins over 200 years ago. The cloth comes in three distinct types, called khanga, kikoy and kitenge. The bulk of the cloth comes from The Netherlands, Java and Japan, although recently textile mills have begun to produce similar cloth in Tanzania and Uganda.

Kitenge cloth is printed in dress or shirt patterns, with collars and sleeves indicated on two-metre lengths. Patterns may be palms, hearts or paisley, among numerous other designs. In America kitenge cloth became one of the trademarks of the "black is beautiful" movement, along with "Afro" hair styles. Kikoy also comes in two-metre lengths, fringed at both ends, in plaid patterns. Wrapped around the waist and falling to the ankles, it is a garment commonly worn by Swahili men. Women prefer the khanga because it holds its shape slightly better and is printed in floral patterns with borders. Khanga often has a Kiswahili phrase printed near the border.

Clothes made from these bright materials are available from numbers of shops in East Africa. In Nairobi most of the cloth shops are clustered along Tom Mboya Street or Bazaar Street;

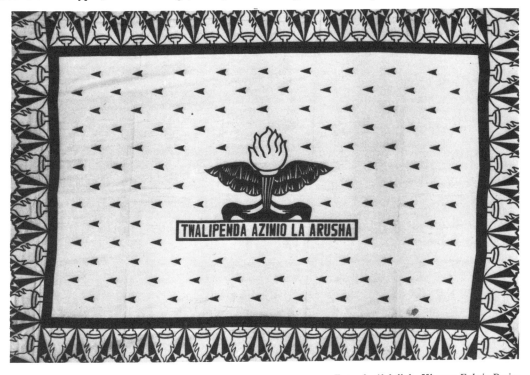

Fatmah Abdallah, Khanga Fabric Design

tailors work on the premises. In Mombasa, where prices are somewhat lower, the cloth shops are on Biashara Street off Salim Road. Similar clothes in the same cloth and patterns are much more expensive at ready-to-wear shops. Such places are more centrally-located and capitalize on buyers who lack time or adventurousness to seek out the cloth in bulk. It is far more satisfactory, and cheaper, to seek out the cloth merchants and tailors who cater to local residents. These shops do immense tourist business as well and the clothes can be made to order in as little as half an hour.

Kikenni Crafts. *Kikenni* means "welcome" and is the name of the Merwin Cowie Estate from which Mrs. Valori Cowie operates Kikenni Crafts. Since 1971 she has taught African women to weave wool. They use a local spinning technique employing their own legs as spindles as wool is taken from whole fleeces. Five small shuttle looms were constructed by Mr. Cowie for use by the trainees. No dyes are used, but variations in tone are achieved by interweaving different colours of fleeces—grey, brown, black and white. The carpets and table mats, wall hangings and shoulder bags made at Kikenni are practically indestructible and can be made to order. Mrs. Cowie uses a more complex shuttle loom in weaving shawls, ponchos, wall-hangings and mats from imported, dyed wools. The goods are sold through the East African Wild Life Society in Nairobi.

Maendeleo ya Wanawake. "Progress for Women" is the translated name of this club for Kenya women. It was founded in 1952 as a non-political, non-sectarian institution. It is dedicated to improving the status and conditions of women and is a member of the National Council of Women of Kenya. Maendeleo sponsors some 2000 rural womens' homemaking clubs, nursery schools and handicrafts marketing for around 80,000 women. Its main district branches are in Nairobi, Kisumu, Nakuru, Mombasa, Machakos and Gilgil. An adult education section gives basic literacy courses,

and other self-help projects have become affiliated with Maendeleo through the Ministry of Co-operatives and Social Services. Dues are 2/= to 5/= a year for group or individual memberships. The club has received monetary assistance from UNICEF, the Department of Community Development and Social Services, City and County Councils, the Ministry of Local Government, many local business firms and various womens' associations around the world.

Around 1964 Maendeleo began the promotion of locally-made handicrafts. Its members are encouraged to make traditional artifacts for sales in the Maendeleo shops (Nairobi and Kangungo, Machakos District). The women receive 80% of the price after the item is sold, but must often wait long periods of time for remuneration due to the lapse between presentation and sale. Maendeleo prices to buyers are low in comparison to those in other shops. Mrs. Jane Kiano, President since 1972, has begun work on turning Maendeleo into a cooperative in which members can share profits instead of waiting for individual payments. In the shops one can find such items as basketry, weaving, beadwork, woodwork, soapstone carvings, toys, tie-dyed cloth and clothes, jewellery and a number of other gift and household items.

A sewing workshop in Nairobi makes clothes to order. Its twenty participants are charged 30/= a month for instruction by Maendeleo staff. The club is also working to raise money for a new building in which the retail shop, offices and sewing workshop can be housed together.

Maendeleo ya Wanawake has a permanent booth in the Trade Fairs at Jamhuri Park, Nairobi, and also exhibits with the Kenya Homes Exhibition, Fahari ya Kenya and national and district agricultural shows. In 1971 Maendeleo handicrafts were exhibited at railway stations between Nairobi and Mombasa during the annual Railway Arts and Crafts Exhibition. Eight Maendeleo members, one from each province in Kenya, visited Nigeria in 1972 to view a similar programme there. Members exhibited basket weaving at the Ideal Home Exhibition in London in 1973.

Maridadi Fabrics. In 1966 Dorothy Udall began teaching five women to do silk-screen printing. They worked at the Home Industries Section of St. John's Community Centre in Pumwani, an impoverished area of Nairobi. The purpose was to provide a livelihood for destitute women. Mary Grayson designed silk screens which the women printed on to cotton cloth. They made some of the printed cloth into tea towels, wall hangings, pillow slips, place mats, napkins, pot holders, neckties and dresses, but the bulk of the produce was sold wholesale by the bolt. Because strict quality control was maintained the project was immediately successful and the grant repaid to St. John's within a year.

In 1967 the Nairobi City Council donated rent-free use of an abandoned brewery near St. John's Community Centre. Maridadi Fabrics has now expanded its programme to include fifty women. They work a six-hour day, and those who wish may take cloth home for cutting and sewing after hours. Extra wages are paid for piece work and total monthly earnings can run from 150/= to 300/=. Some thirty fabric designs are produced in forty-five colour combinations, usually in cotton cloth although other material can be used on order. The business is concerned solely with filling wholesale orders, mainly as exports. It works to capacity, usually with more orders than time to fill them.

Since 1967 Mrs. Martha Gikonyo has managed Maridadi (means "fancy" or "pretty") Fabrics. She has a staff of five Kenyan women and reports to a committee of representatives from St. John's Community Centre. Patterns for the cloth are sometimes commissioned from free-lance artists (among them Tom Kiyegga, Francis Malinda, Simon Mwangi). Efforts are being made to encourage more local designers to participate and to use motifs found in traditional African art.

The workshop is open to the public on Tuesdays and Thursdays for retail sales of "seconds", further proof of the consistent quality control. Recently a tailoring department and a dress shop

Maendeleo ya Wanawake, Sisal Weaving
Photo Daily Nation

have been added. The workshop is an interesting place to visit. The atmosphere is busy and convivial; women wear head-dresses of Maridadi cloth and leave their babies to play in an adjacent courtyard. In Nairobi, Maridadi Fabrics are sold in numerous retail shops.

Masai Shops. The Masai tribesmen sell traditional handicrafts at several buying posts in Kenya and Tanzania. The items are usually new pieces made in the authentic tribal manner using traditional materials. Beadwork belts, jewellery, calabashes, spears, shields and a number of small items such as snuff boxes and cow bells are for sale at reasonable prices or whatever the market will allow. Occasionally one may find rare items such as terra-cotta dolls once used for ceremonial purposes.

Nairobi Group. Mrs. Wilma Snell, a qualified handicrafts teacher from Washington, D.C., set up a small enamelling workshop on the grounds of her Nairobi residence in 1969. The facilities there included a kiln and other materials brought from the U.S. Mrs. Snell, with Mrs. Erica Mann, a local architect and town planner, taught the eight members techniques of enamelling on copper. The following year the Nairobi Group (which included students, artists and some of the Snell's household staff) showed their work at Gallery Africa. Soon they were supplying jewellery and decorative items to Studio Arts 68, Elite International, and Waa, The Bright Spot. Since 1971 the Nairobi Group has exhibited at various trade shows and fairs in Nairobi. Forty per cent of the income from sales goes towards buying new supplies and to paying off Mrs. Snell's original investment. The rest goes to the artists.

When Mrs. Snell left Kenya in 1971 the Nairobi Group was moved to the Mann residence where Mrs. Mann continues to supervise. Traditional

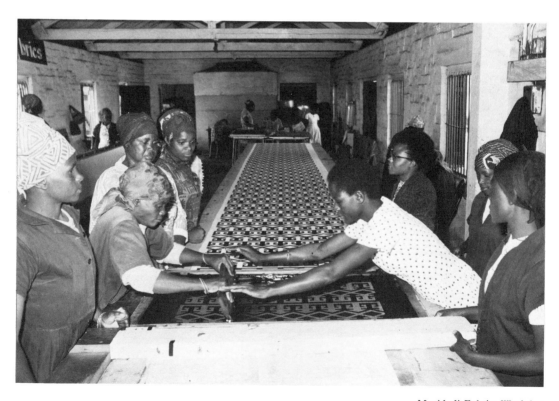

Maridadi Fabrics Workshop

African designs are enamelled on to jewellery, belts, ashtrays, bookends, wall hangings and other gift and household items. Since 1971 all the copper bases, chains and hooks have been bought from the Kenya Rehabilitation Centre. Most of the original members are still with the Nairobi Group.

Ngubi Maendeleo is a handicraft centre organized within a township on the Naivasha road just outside Nairobi. It has no outlet shop; the artisans hawk their wares from the sides of the highway, holding up sheepskin hats, sisal chairs, mats, tables and pottery (often still in production) for the inspection of passing motorists. Prices are anything the market will allow. A unique institution, the Ngubi Maendeleo creates handicrafts quite unlike others in Kenya.

Prison Industries. Prisons in East Africa sponsor crafts workshops as rehabilitation centres in a programme initiated in 1965. Workers are allowed a small income from sales of the items they make. Handicrafts are much the same as one may find at other crafts centres and prices, too, are similar. One advantage of the prisons industries to buyers is that designs may be commissioned in furniture, carpets, metalwork, carvings, beadwork, basketry, jewellery and numerous other items. A time lapse of several months can be expected between order and completion. The main prison industries showroom in Kenya is on Langata Road in Nairobi, across from Wilson Airport. Three smaller showrooms are at Manyani (between Voi and Mombasa on the Mombasa Road), Shimo la Tewa (between Mombasa and Malindi) and Kisumu (western Kenya). Prison-made artifacts are exhibited at national and district agriculture shows.

In Tanzania prisoners may receive crafts training at National Development Corporation workshops or in the prisons themselves, Kingolwira

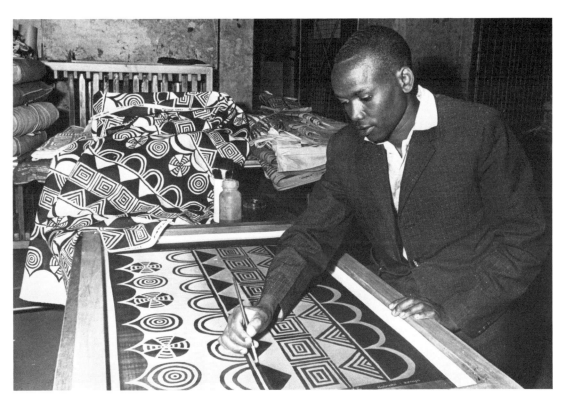

Simon Mwangi, Maridadi Fabrics Design

61

Prison in Morogoro and Ukonga Prison in Dar es Salaam. In Uganda prisoners sell their handicrafts through Government crafts markets in Kampala. In 1967 a Prison Industries Handicrafts and Farm Show was held in Murchison Bay Reserve, Uganda.

Skanda's Wood Workshop. The island of Lamu, off the coast of Kenya, was once renowned for fine craftsmanship in chests, doors, furniture and household utensils and decorations. Today these items are rare and the beauty and originality of their designs highly prized. The Kenya Government has banned the export of old doors in an attempt to protect such places as Lamu and Mombasa.

Local demand for chests, doors and furniture has practically ceased. In Lamu today one woodwork shop, owned and operated by Abdalla Ali Skanda, stays in business largely by doing repairs. However, one can still commission Bwana Skanda to design and make new doors, as have Lord Delamere and H.I.H. Emperor Haile Selassie II. Skanda will also make new tables, shutters and furniture to order as well as miniature *dhows* (Arabian sailing ships) beautifully detailed and painted. He recently made doors, lintels and lamp brackets for the Serena Beach Hotel in Mombasa.

As one of the last of the Lamu wood craftsmen, Bwana Skanda is something of a monument. One hopes he will find an able apprentice to carry on the work after him.

Studio Arts Co. Ltd., is one of the most successful crafts businesses in Kenya. It sells a wide variety of authentic and redesigned handicrafts made by local people. Dozens of craftsmen are employed, many of them working in studios provided by Studio Arts. Others work on their own and sell their crafts exclusively at Studio Arts 68, usually under contract. A great deal of redesigning is done to cater to modern use and western taste. Much of this was the work of the first director, Sherry Hunt. Mr. S. T. Kairo became director in 1973. The success of the business is ensured by good

advertising, an attractively decorated shop in a choice downtown location, well-trained salesgirls who also model garments, and many public events such as fashion shows, artists' demonstrations and exhibits of traditional art. An adjunct staff collects ethnic artifacts from all over East Africa and from as far away as the Comoro Islands and Madagascar.

Vocational Rehabilitation Centres. The Kenya and Uganda Governments run training programmes to help disabled citizens gain social and economic independence. The project in Kenya is organized under the Ministry of Cooperatives and Social Services by the Department of Community Development, the Division of Vocational Rehabilitation. Original support and advice were given by the International Labour Organization of the United Nations in initiating a five-year plan emphasizing the rural aspects of rehabilitation and vocational training. Many volunteer organizations have become involved, including The Association for the Physically Disabled, the Kenya Society for the Blind, the Red Cross, the Salvation Army, the Kenya Society for Deaf Children and the Kenya Society for Mentally Handicapped Children. The project also works closely with mission societies and currently employs members from international volunteer agencies in Denmark, Germany, The Netherlands, Norway and the United States.

In the "Sheltered Workshops" thus established, disabled people who are too severely impaired to do a normal day's work are given hostel and workshop accommodation and taught to make either jewellery, leather goods, desertwood and soapstone carvings, carpets, silk-screen prints, enamelware, clothing, wrought-iron or copper ware or to renovate used articles. Once they have achieved some facility participants are employed by the workshops at standard wage rates. There are workshops in Lamu, Nairobi and Mombasa.

Among the outlet shops for these products in Kenya are Waa, The Bright Spot in Nairobi and Studio Sanaa in Mombasa. The latter deserves special comment because it is a beautiful shop

expertly decorated and run by Noel Gateja. Peace Corps volunteer Holland Millis did the original decor. The shop sells a sampling of handicrafts from Lamu, Somalia and Uganda, along with the items mentioned above, at exceptionally reasonable prices. The excellent standards of the managers make this shop a delight to see and the artifacts it sells often real finds.

YMCA Crafts Training Centre. The YMCA has since 1966 sponsored a Crafts Training Centre at its premises in Shauri Moyo, a low-income district of Nairobi. A modern building and facilities were financed by the YMCA in Germany and Canada, the Nairobi Rotary Club and other organizations and private people. A two-year course is offered to groups of three or four Standard VII primary school leavers who show financial need and want further education along with occupational training. The YMCA donates materials and facilities and gives regular primary school courses in addition to handicrafts training in batiks, enamelwork, ceramics, leatherwork and woodwork on furniture and toys. Students must specialize in one of these areas for two years, after which they are assisted, in teams, to start small home industries on their own. Thirty-three such teams now exist; they plan to merge as a co-operative industry. Some of the students are handicapped and all the leatherworkers are partially blind. The centre, for several years under the direction of F. Albert Schwarz, is now headed by Helmut Köhl; Mr. Barongo is assistant director. The director and three foreign instructors will be replaced by Kenyan counterparts.

Products from the YMCA Crafts Training Centre are shown at an annual Christmas exhibition at the Nairobi Hilton Hotel and at the Kenya

YMCA Crafts Training Centre Photo Fritz Dieter

Homes Exhibit held each year at City Hall. Works are on sale at the Y'Crafts shop, next to the Nairobi Cinema, in numerous other shops all over Kenya and at the Shauri Moyo workshops. Exports go to Germany, England, the United States and Canada.

YWCA. In Nairobi the YWCA runs a tailoring workshop where the public may have clothes made or altered.

<div align="center">TANZANIA</div>

National Cottage Industries Corporation of Tanzania. The Tanzania Government has undertaken the task of supervising all cultural activities in the country. They have sent artists and artifacts abroad, to Expo '70 in Japan and to a painting exhibition in Moscow in 1971. Also that year the Tanzania Government signed a five-year renewable agreement with the German Democratic Republic for cooperation in education, public health, sports and culture. Subsequently the GDR financed Tanzanian delegates and students on a cultural visit to Germany.

The National Development Corporation, a government body which heads the National Arts of Tanzania, established the National Cottage Industries Corporation in 1965. Training in crafts production and business management is offered and students are assisted in establishing cottage industries upon completion of the course. Many participants are Standard VII primary school leavers. Others are prison inmates who are allowed to participate under special supervision. Students take a one-year course from the National Cottage Industries Corporation in either metalwork, carpentry, weaving, bamboo work or basketry. They then are expected to return to their villages to set up cottage industries. While in training, hostel accommodation is provided at centres in Dar es Salaam, Moshi, Singida and Mwanza. Finished products are either exported or sold at crafts shops in Tanzania. Proceeds are used to buy more raw materials and to run the centres.

The NDC also runs the Friendship Textile Mill, the National Textile Industries Corp., Ltd. and Mwanza Textiles, Ltd. All employ local designers and through the Corporation's magazine, *Jenga*, the public is encouraged to submit textile designs. A basketry and weaving centre for girls in Upanga and a gemstone cutting plant in Arusha also come under the NDC. Items sold through NDC are subject to quality controls and those that pass are given an NDC official stamp of approval.

Umoja wa Wanawake wa Tanzania. "Unity of Women of Tanzania" is sponsored by TANU, the Tanzanian political party. It has an estimated 30,000 members. For 5/= yearly dues, members receive such services as child care and vocational training from UWT branches in each village in Tanzania. Mrs. Sofia Kawawa (wife of the Vice-President of Tanzania) is the club's permanent president. Mrs. Ngaia is managing director. In 1971 the club came under the aegis of the National Development Corporation. Since then it has initiated plans to build a hostel for girls in Arusha, open a consumers' cooperative shop and publish a book on baby care.

Handicrafts production is a very small part of UWT's total activities. Handicrafts made by members are sold from the UWT headquarters in Dar es Salaam. An exhibition was held there in 1971.

YWCA. The YWCA of Tanzania has a small, well-stocked shop in Dar es Salaam. Here attractive handmade clothes, baskets, table linens, greeting cards and tie-dyed cloth are for sale at very reasonable prices. The clothes were designed by a Norwegian volunteer and made by local YWCA members. Styles are as modern and imaginative as those found anywhere in East Africa.

<div align="center">UGANDA</div>

Brother Joseph's Stained-Glass Studio. Since the 1950s Brother Joseph, a Dutch priest of St. Joseph's Society of Mill Hill, has operated a

Lamu Door. Photo Esmond Bradley Martin

Lamu Door. Photo Judith Miller

stained-glass studio at Nsambya Mission in Kampala. His only training was a five-week apprenticeship at a similar studio in Holland. He has now made stained-glass windows and leaded lights for churches all over East Africa. His local apprentices, once fully trained, are employed at 250/= to 300/= a month to help him with the technical work. Brother Joseph does all the designing himself.

The studio and Brother Joseph have received some gratifying external assistance and recognition. The glass is imported duty free and sales tax is waived as a courtesy of the Uganda Government. A Netherlands firm contributed a station-wagon for transport. In 1963 Brother Joseph was given the papal decoration "Pro Ecclesia et Pontifice" by the papal delegate for East Africa. More recently he received the Knighthood of the Order of Orange-Nassau from the Queen of The Netherlands.

This unique workshop is often utilized by the Makerere School of Fine Arts. Margaret Trowell took her students there for instruction and the present Makerere faculty has done the same. Under Brother Joseph's guidance Makerere students and faculty have made stained-glass windows which are now in churches all over East Africa.

Plans are to move the studio to the compound of the Little Sisters of St. Francis, partly to be nearer Makerere, partly to establish a successor to Brother Joseph. One of the Little Sisters is apprenticing now. After the move all materials will become the property of the Little Sisters.

Stained-glass windows from the Nsambya studio may be seen in fifteen dioceses in East Africa and there are still more orders than time to fill them. Prices are from 3000/= to 5000/= for windows and/or leaded lights for an entire church. Designs are in religious motifs with African figures. Notable windows in Uganda are at Lira Cathedral in Lira, St. Augustine's Chapel on the Makerere campus and Sister's Convent in Mbuya. In Kenya, Brother Joseph's windows may be seen at St. Austin's Church in Nairobi, Karbui Church in Kapsabet and the Nyabururu Mission and Bishop's house in Kisii.

Uganda Crafts. In 1966 a handicrafts scheme was initiated by the Uganda Ministry of Culture and Community Development. It was originally intended to benefit womens' clubs, but has expanded to include men and women from every district in Uganda. Goods are solicited from villagers in an attempt to encourage the production of traditional handicrafts. Centres take a small percentage of the sales profits to cover running expenses; the rest goes back to the villages. An illustrated catalogue is distributed through the Uganda High Commissions and Embassies all over the world. It pictures and classifies several hundred items of weaving, household ornaments and utensils (adapted for European-style homes), furniture (for Ugandan homes), bark cloth, musical instruments, arms and weapons, personal ornaments and skin goods (for the urban and foreign markets). Most of these items are of original, traditional designs used by Ugandan tribal groups.

Brother Joseph, Stained-Glass Window
Nyabururu Mission

The Uganda Handicraft Emporium on Kampala Road was the original commercial outlet for these items. In 1970 The Crafts Market opposite the Grand Hotel in Kampala was opened, with another branch in the International Hotel. All the outlet shops are run by the Ministry of Culture and Community Development.

Uganda Development Corporation Pottery Project. The Uganda Development Corporation is a government body dedicated to assisting all phases of development in the country. It has given a number of small grants to individuals wishing to set up cottage industries. In 1958 it assisted Michael Gill in establishing a new pottery industry in Uganda.

Gill started a training workshop at the Kampala Technical Institute. It was equipped with potters' wheels, clay and a kiln. Students were invited to sit in on one year of free observation. The second year students paid for formal instruction through the sales of the pottery they themselves made at the workshop. Graduates were encouraged to apply for scholarships to pottery workshops elsewhere in the world. Some graduates went on to the Abuja Training Pottery in Nigeria to study with Michael Cardew or to Bernard Leach's pottery in England. Several students who went through the entire programme were given UDC loans to set up their own potteries in Uganda.

As an additional part of his service Gill drew up plans for a building which could easily be erected as a pottery. He pin-pointed several locations in Uganda where clay, wood (to burn in the kilns) and water were plentiful and designated them as possible pottery sites. Gill's plan was for the trained potters to set up their own potteries in the rural areas. They would then make utensils for use by local people, tying in their newly acquired training with what they already knew of local traditions and needs. When Michael Gill left Uganda in mid-1960 the workshop at the Kampala Technical Institute was closed. Two potteries were set up as a result of his efforts.

Namanve Pottery was built in 1963 and is run by Ed Kalule and others. It produces an assort-ment of glazed jugs, pots, beer mugs, vases, cups, pitchers and lampstands. It is supported solely by sales to tourists or people in middle income brackets. Prices are out of reach to most local people. The main sales outlets are on the Namanve premises and through the government crafts markets in Kampala. Busega Pottery was started in 1961 by Martin Luther Kasirye with the help of his family and three paid assistants. Prices for his selection of unglazed flower pots, water coolers and glazed mugs and sugar bowls are geared to the local economy. Most of his wares are sold in shops in Kampala.

Vocational Rehabilitation Centres. These centres come under the Ministry of Culture and Community Development and were begun in 1965 with funds from Oxfam and the Danish and Japanese Governments. As in Kenya, the project was organized by the International Labour Organization of the United Nations.

At Kireka Industrial Rehabilitation Centre, 138 disabled people make umbrellas, bamboo objects, leather goods, silk-screen prints, iron goods, desert-wood carvings and other handicrafts, or learn carpentry or tailoring. All marketing of the finished products is through the Ministry of Culture and Community Development to retail outlet shops in East Africa, government markets in Kampala and a small shop on the Kireka premises.

The Masaka Cloth Printing Factory specializes in silk-screening on to locally-produced cotton. A Danish volunteer, B. Petersen, did much of the designing of patterns and training of workers. The cloth reflects a Scandinavian influence and is very attractive.

Other centres in Uganda are the Lweze Centre for leatherwork, Bwana Centre for bamboo work, Mbale Centre for canvas and tarpaulins, Ruti Centre for leather and handicrafts, Jinja Centre for canvas goods and toys and Gulu Centre for hats and dresses in plain and handprinted cottons. Other rural vocational rehabilitation centres are in West Nile, Ankole, Kigezi and Bugisu.

At the Nangabo Self-Help Centre near Kasanga

participants make batik cards. Rural training centres for women are run by the National Committee of Catholic Women, the YWCA and the Department of Community Development. All produce from these workshops may be purchased at government handicrafts markets in Kampala.

University and College Art Schools

The colonial governments of East Africa (which withdrew from power in the 1960s) gave art projects a low priority rating. A university art school would not have come into existence in the territory as early as it did had it not been for the perseverance of one woman. The second university art school did not open for another 25 years. University officials had originally planned to divide the arts into three sections, one taught at each of the three university campuses: fine arts, graphic design and architecture, and theatre arts. Today, however, such diversifications are unjustifiable since the three campuses no longer operate as one University of East Africa.

Students come to the university art schools with little background in art. Although all public school curricula include painting, and some even offer sculpture, most programmes are extremely limited. Materials such as paints, clay, wood and stone are difficult to budget in the face of other seemingly more pressing needs. Primary and secondary school students are lucky to have two periods of art a week. A few schools have extremely interesting art programmes, but these are rare.

One could argue that art schools do not make artists. But as traditions of ancient art are no longer a memory for many East Africans, art schools can help reawaken an interest in culture. The best artists in East Africa teach at its universities. These institutions provide rare sanctuaries where art is considered seriously and would-be artists can receive beneficial instruction and criticism.

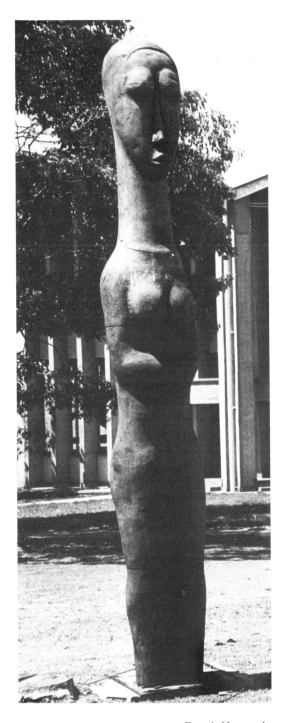

Francis Nnaggenda,
"Girl in a Mini". Nairobi University Exhibition
Photo Daily Nation

67

University of Nairobi Department of Fine Art. At the Royal Technical College of East Africa, which opened in Nairobi in 1956, the art and architecture departments were inter-dependent and all art courses were geared to assisting the Department of Architecture. In 1961 the renamed Royal College Nairobi began to work away from the technical bias which had pervaded the Art Department. In 1963 the renamed University College Nairobi instituted a Faculty of Architecture and Design. Fine art was taught only at Makerere University in Kampala and theatre arts only at the University College Dar es Salaam. In 1969–70 a Department of Fine Arts was opened at the now University of Nairobi shortly before the three campuses became independent universities. Some internal disagreement still exists as to whether or not to continue the established divisions of the art departments.

A three-year B.A. in art is now awarded at the University of Nairobi under Professor Gregory Maloba, Head of the Art Department, and lecturers Tag Ahmed, Terry H. Hirst and Louis Mwaniki. Facilities such as books, work space, materials and exhibition space are still minimal. A new Faculty of Creative and Cultural Arts has been appropriated money for a building. The Faculty will teach theatre, music, dance, painting and sculpture. The new arts building will provide more classroom space but workspace will still be a problem. The Department of Fine Art syllabus contains mainly practical courses with one quasi-historical course. Future plans are to add to the curriculum and workspace.

University of Nairobi Institute of African Studies. In 1961 the Institute for Development Studies of the University of Nairobi introduced a cultural division. It became a separate entity in 1965 known as the Institute of African Studies. Its aim is to organize and direct research into the cultural heritage of Kenya. Seven projects have been approved as having high priority research needs. As of 1972 these included:

The National Archaeological Survey and Salvage Project, to discover, evaluate and publicize archaeological sites which might otherwise be destroyed by natural causes or uninformed human intervention. Field studies in the history of architecture of Kenya are also carried out under this project.

The Art Project, to encourage and create contemporary sculpture and painting.

The Kenya Belief Systems Project, to collect and study traditional cosmogonies, social values, religious beliefs, myths, legends and general environment management.

The History Project, to collect, record, collate, analyse and write up histories, especially oral and archaeological.

The Linguistics Project, to collect selected lexical items and record grammatical systems for better historical perspective and modern descriptive analysis.

The Kenya Material Culture Project, to collect and classify artifacts from every tribe in Kenya and to study the technical methods of their production.

The Music Project, to collect, record and transcribe traditional and "neotraditional" songs, instrumental music and dance and to classify musical instruments.

The Institute's newsletter, *Mila*, is published twice yearly with accounts of the progress of each of these projects.

Kenyatta College. A national teaching college for secondary school teachers, Kenyatta College opened its Art Department in 1965 with a general course in art methods. In 1967 the Department included studios for painting, sculpture, pottery and graphics. In an attempt to define the role of the emerging African artist, the staff, under Head Terry H. Hirst, implemented many liberal and innovative teaching methods. Students painted murals on the art building which are continually overpainted as they age or fade. A 1968 exhibition included works in over twenty media. Traditional crafts are examined and new materials used in their creation. By 1970 more than sixty art

teachers had graduated from Kenyatta College. Many sought positions in rural schools, seeing the grassroots as the basis of African culture.

From 1966–70 the faculty included Ursula Sutton-Briggs, Frank Foit, Terry Hirst, Elimo Njau, Loloshy Sagaaf and Elphas Webbo. Since 1970 it has included only Mrs. Briggs, Catherine Gombe and Ghanjal Singh. Students spend an equal amount of time in each studio per week, at self-appointed hours. To complete the art course students must submit an illustrated "special study" relating to some aspect of creative activity practices in their home regions. The Art Department is building a library of the first-hand information and original texts obtained from students. Some of these are "Kikuyu Songs from the Emergency", "Luo Pottery", "House Construction in Meru", "Hindu Temple Sculpture", "Kalenjin Ornaments" and "Calligraphy and the Koran".

Some special studies deal with dance and ritual. The College dance-drama group, Zukeni, was formed around a nucleus of art students. They collect dances, songs and drumming from all over Kenya and incorporate these into new or traditional choreography. Zukeni has performed for President Kenyatta at his home in Gatundu and at Paa-ya-Paa Gallery and have arranged a series of exchange dances with village groups.

TANZANIA

College of National Education, Art Department. The College of National Education at Chang'ombe opened its Art Department in 1972. Ten students graduated in 1973 and another fourteen in 1974. An exhibition of students' work was held at the National Museum in Dar es Salaam in 1974.

University of Dar es Salaam Institute of Adult Education. In Dar es Salaam art courses are occasionally offered at the Institute of Adult Education, a branch of the University of Dar es Salaam. Scheduling of classes is irregular and

Kenyatta College Art School

occurs when a member of the Society of East African Artists offers to teach it. Luis Mbughuni and Elias Jengo, both University faculty, have been among the volunteer art teachers. Although no department of art exists on campus, art training is often a part of such courses as Stage Design and Fine Arts Education. An annual Arts Festival is sponsored by the Theatre Arts Department.

Makerere University's Margaret Trowell School of Fine Arts (also referred to as the Makerere School of Fine Arts). The oldest art school in East Africa is named after its founder, Margaret Trowell, who started giving art classes at her Kampala home in 1936. In 1939 the so-called "compulsory hobby" became a minor subject at Makerere University. In 1942 it became a major in the Higher Arts Certificate course and in 1949 a Department of Art with a 3-year Teachers Certificate course.

Mrs. Trowell procured the sympathy and guidance of the Slade School of Fine Art of the University of London in establishing a 4-year, full-time Diploma of Fine Art at Makerere. The degree was awarded for the first time in 1957. As art could not be included in the curriculum under the "special relationship" Makerere then had with the University of London, the art school was made a separate unit within Makerere University. In 1969 a B.A. in Fine Arts was introduced along with the Diploma. The first Ph.D. in art was awarded in 1970 and a number of students are now taking post graduate work in art with faculty Ali Darwish, John Francis, George Kakooza, Jonathan Kingdon and Therese Musoke.

Work space at Makerere is good although not elaborate. The oldest art building, which houses the painting and graphics studios and a photographic drafting and dark room, was at one time the Uganda Museum. A separate building erected with Commonwealth Development and Welfare funds in 1960 holds lecturers' offices, a lecture room, a life drawing and painting room and a spacious modelling, sculpture and metalwork studio. A nearby University administration building became a students' hostel, then was gutted and rebuilt as the ceramics department.

The showpiece of the art school is the Makerere Art Gallery opened in 1969 with funds from the Calouste Gulbenkian Foundation. Its collection includes works by Makerere staff and top students gathered since 1937.

Courses now include general studies; art history; modelling and sculpture (clay, wood, stone and metals); graphics (illustration, etching, silk-screen, lithography, typography and photography) and ceramics (traditional and modern studio and industrial techniques). The ceramics department has done research for industrial ceramics firms in Uganda. The Diploma art course may be followed by a Diploma in Education, the total six years equivalent to an academic degree. Courses in visual arts are given to African Studies degree candidates by the School of Fine Arts. Students have gone on for post-graduate work at such institutions as the Slade School of Fine Art, The Royal College of Art, London, the Academy of Turin, Italy, and the Ecole des Beaux Arts, Paris.

Art school activities have been innovative and have given students a broad range of experience. Commissions for art works on public buildings are often offered to top students. *Roho*, a magazine of the visual arts, was produced and edited under the direction of Senior Lecturer Jonathan Kingdon. It featured articles and illustrations by Makerere students and staff and was the first colour-illustrated magazine in Uganda. In 1955 the Calico Printers' Association, Ltd., Manchester, bought textile designs from Makerere students. The art school has also produced a number of major exhibitions, such as those celebrating the independence of Tanzania and the independence of Uganda, the "Nile Centenary Festival" with the Uganda Arts Club and "Christian Themes" in Makerere's St. Francis Chapel.

Art Societies

The several original art societies in East Africa involved groups of dues-paying "Sunday painters" who met regularly to pursue a common artistic avocation. Some of these societies still exist, amplified to include multiple-course curricula with members who pay tuitions to defray costs of teachers and supplies. The produce of such societies is usually displayed in annual public exhibitions.

In addition to societies for amateur artists other types have emerged more recently. One is composed of professional artists, another of art patrons. Both address themselves to improving conditions for artists in East Africa. Because of the somewhat formal nature of these societies, and the necessity of paying dues, they do not attract the general public. But those which provide art classes perform a needed function. In all cases such societies are privately run and are self-supporting. The following does not exhaust the list of art societies in East Africa, but names some of those most commonly known.

KENYA

Kenya Arts Society was founded in 1922 by a Nairobi settler group. In 1951 it came under the management of its present principal, Mrs. D. F. Betts. Classes are taught by Mrs. Betts in oils, watercolour, life-drawing, portraiture, flower arrangement and various handicrafts. The Society's 250 members meet in classes of 20 to 40, three times a week, in the Arts Society building. Fees are from 120/= to 180/= for twelve classes, or 72/= for African students. The premises are rented from the Kenya Girl Guides who manage the extensive grounds. Mrs. Betts, the sole staff and an artist in her own right, was selected by the board of trustees. A small shop sells students' works and an annual exhibition is held at City Hall. The Society also manages the annual Esso Competition. Kenya Arts Society students may take the London University examination for accreditation in order to attend higher art schools.

Creative Art Centre was founded in Nairobi in 1965 by Mrs. Batul Nadiadi, the sole staff. Mrs. Nadiadi teaches courses in advanced drawing and painting, commercial art and graphic design, interior decoration and specialized art courses. The present 100 students (the maximum the facilities will allow) are given free materials with the exception of oil paints. Fees range from 60/= to 95/= for a beginners' one-month course to 200/= to 800/= for six-month courses for advanced students. The Ministry of Education cooperates with the Centre in awarding certificates to its graduates, after three years for fine arts students, one-and-a-half years for commercial arts students or one year for those in interior design. Graduates can go on to the Makerere Department of Education for another year to complete a teachers' training course.

Annual exhibitions are held at Oshwal House or the Kenya Polytechnic Institute. Students who sell works at these exhibitions are entitled to any profits; sometimes these can amount to enough to cover their school fees. Students are also encouraged to take jobs with local firms doing monograms, designing, window displays and related matters.

In 1971 the Creative Art Centre founded Evolutionary Versatile Artists, an organization for students, artists and other interested persons. Subscriptions of 10/= a year for students and 20/= for adults entitle members to attend lectures and films and to receive a news magazine. Proceeds go toward scholarships to the Creative Art Centre and to finance its annual exhibitions.

Kenya National Art Foundation. A small group of patrons of the arts established the Kenya National Art Foundation in 1966. Its purposes are to establish a permanent art collection in Kenya, to encourage indigenous arts and engender art appreciation, to assist local artists and encourage visiting foreign artists, to set up art centres and galleries all over Kenya and to promote East African art abroad. Early activities included an auction of works by Kenyan artists at the residence of the United States Ambassador to Kenya. A

Franca Ghitti, Stained-Glass Window
Photo Harald Nickelsen

Young Artists Exhibition was co-sponsored by the K.N.A.F. and the Ministry of Education. A permanent collection now includes works by Picasso, Braque, Chagall, Laurens, Hartung, Poughiny and Bazaine, all privately donated. As no art museum exists in Nairobi these works have been lent to the Commercial Bank of Kenya and the University of Nairobi for display. In 1967–68 the K.N.A.F. gave a 1000/= bursary to artist Simon Mboga to cover two years of school fees and art lessons. In 1969, 4000/= was donated to the Kenya Arts Society.

By 1971 many of the founding officers and members had dispersed and Joseph Murumbi and Peterson Kareithi resurrected the Foundation. Mr. Kareithi is now chairman. Two sub-committees were established to raise money and to obtain a plot of land or a building for a gallery. Fifteen new members were enrolled; membership is 40/= a year. Regular meetings and subscription of new members continue.

Kenya Museum Society. The Kenya Museum Associates was founded in 1967 by Richard Leakey and revitalized in 1971 under its present name. The new board of trustees includes, among others, B. A. Gecaga, Prof. G. Maloba, J. P. Murumbi, Dr. N. Mungai, Prof. B. A. Ogot and P. Olindo. The acting committee is headed by Dr. E. B. Martin. The Society's purpose is to create interest in the museums of Kenya by sponsoring activities associated with the museums and to raise money for their continued support. Yearly membership of 25/= (families 50/=, overseas members 70/=) entitles one to the Society's quarterly journal *Kenya Past and Present*, admittance to one major City Hall exhibit a year, free entrance to any of the museums of Kenya, lectures and movies at the National Museum in Nairobi and special tours to points of interest in Kenya.

Since 1971 the Kenya Museum Society has sponsored such major City Hall exhibitions as "The Lake Rudolf Fossils" directed by Richard Leakey and "The Art of Lamu" directed by James d. V. Allen. Other activities have been an

eight-week course for museum guides. The Society's publications include the *Safari Colouring Book* by Doris Block and a German translation of Dr. E. B. Martin's *Malindi Past and Present*. The Society has also established a film programme at the National Museum and made a grant to the Museum's Education Section and a loan to the Lamu Museum.

The Society of East African Artists. At the first meeting of the Community of East African Artists in 1964, Sam Ntiro was elected chairman, Elimo Njau Secretary-General and Eli Kyeyune Treasurer. Its initial exhibit opened at the National Museum in Dar es Salaam that year and was attended by Tanzania President Julius Nyerere. Later that year another, larger, exhibition was held at the opening of Chemchemi Gallery's new premises in Nairobi. In 1969 the C.E.A.A. was reorganized and renamed the Society of East African Artists. It is still headed by Ntiro.

This group of around fifty artists meets yearly in one of the East African capitals for a two-week workshop. Art made at the workshop is then sold at a public exhibition. Members, most of whom are professional artists, are asked to contribute 150/= a year to ensure continuation of the Society's objectives: to arrange painting workshops, exhibitions, occasional seminars and discussions of the importance of culture in East Africa and to elicit the interest and support of anyone concerned with East Africa's cultural heritage. Membership is open to all artists in East Africa.

In 1969 the Society of East African Artists, with the Tanzania Community Development Trust Fund, sent 102 paintings to New York for exhibition at the Union Carbide Building. Proceeds benefited both the S.E.A.A. and the Community Development Trust Fund (which promotes self-help projects in Tanzania). In New York the exhibition was sponsored by the Tanzania Committee of the U.S. Community Development Foundation, a cooperating agency of the Save the Children Federation. Total proceeds from the exhibition came to over 700,000/=. Sam Nitro

presented Tanzania Vice-President Kawawa, as chairman of the Community Development Trust Fund, with 50,000/= as his share of the profits.

Tanzania Arts Society. Tanzanian artists, for 5/= a year, may join the Tanzania Arts Society. It was founded by a colonial settler group in the early 1940s. In 1964 Sam Ntiro, as Commissioner of Culture, became its head and initiated regular weekly art classes. Students bring their own materials to the workshop in Mnazi Mmoja Primary School in Dar es Salaam where they are given instruction by a member of the Society of East African Artists. Live models are also provided. Exhibitions of members' works are held annually at Saba-Saba Day celebrations in Dar es Salaam (celebrating the birth of the political party, TANU). In 1970 the Tanzania Arts Society was granted exhibition space at the Kilimanjaro Hotel mezzanine and thirty paintings are kept up for sale in a rotating exhibition. Funds go towards a building for the Society.

Tanzania Crafts Council. In 1959 a group of colonial settlers founded the Tanganyika Arts and Crafts Society as a service to amateur artists and artisans. In 1964 this organization was revitalized and membership opened to all citizens of the United Republic of Tanzania. Its presiding officers were Bibi Titi Mohammed, then Parliamentary Secretary to the Ministry for Community Development, and Sam Ntiro, then National Cultural Deputy. Ntiro continues to chair the Council today. The Council was planned as a branch of the World Crafts Council (an international body which meets regularly in one of the member countries) of which Ntiro is General Secretary. Branches of the Tanzania Crafts Council were planned all over Tanzania. They were to provide work space, materials and tuition for craftsmen and exhibitions of their works in Tanzania and abroad. Works accepted by the Council for public sale were submitted to a panel of judges who allotted fixed prices according to certain agreed criteria.

Initial interest in the Council was good. The

object, to raise and maintain standards of Tanzanian crafts and to arrange for their exhibition and sale, was implemented by a brochure illustrating 148 carvings and baskets available from the Council. Meetings are held when space can be obtained and members organized; members sometimes work at the Village Museum outside Dar es Salaam. Exhibitions are held whenever a body of work accumulates and are usually planned for such public occasions as Saba Saba Day. In 1970 Tanzanian handicrafts were sent to the Arts and Crafts International Fair in Florence; all were sold the first day. Yearly membership in the Tanzania Crafts Council is 5/=.

Tanzania Society of African Culture Founded in 1964, this Society's aim is to act as an umbrella to help individuals or groups of Tanzanians to spread artistic and cultural activities. Under Chairman W. K. Chagula the Society works in cooperation with the Tanzania Crafts Council.

UGANDA

Uganda Arts Club Margaret Trowell founded the Uganda Arts Club in 1952. She used the Makerere Art School facilities to give classes in life drawing, clay modelling and still life painting. She also arranged sketching parties, group discussions of art and an annual exhibition of members' works. Members are amateur artists who pay an annual subscription of 10/=. At the Club's founding fifty members were enlisted; today there are around one hundred and twenty. The Club once organized the Esso Standard Calendar Competition, now no longer held in Uganda. It also organized the opening exhibition for the Bank of Uganda. The Bank bought several dozen paintings from the Club with which to decorate its premises. The annual Uganda Arts Club exhibition is held at the International Hotel in Kampala and paintings are exhibited there all year courtesy of the Hotel. The Club takes a 15% commission on any paintings sold; the rest goes to the artist.

The present president is Charles Sekintu, Director of the Uganda Museum. The organizing and teaching is done by the Club's secretary, Mrs. Joyce Heijboer. Activities have been curtailed in the past few years because of lack of funds. Free lessons with free supplies can no longer be offered, but exhibitions are still organized, particularly on national occasions. Non-members may exhibit along with Arts Club members, and professionals are encouraged to do so. A permanent display of Arts Club work is in the foyer of the Uganda National Theatre in Kampala.

Art Competitions

One of the ways East African artists can earn money or temporary publicity is to win an art competition. First prizes can be as high as 3000/= and 12,000/= and the publicity, while it lasts, may bring the winner a few sales of his art works. Most competitions are advertised through local newspapers, art schools or art societies. Judging has been unbiased within stated bounds and participation has been good. Many competitions have resulted in works of art being designed by winners for public buildings in East Africa. A few competitions are regular events, such as the annual public school competitions sponsored by ministries of education, and other competitions sponsored by local firms and associations (as the Freedom From Hunger competition). The impact of competitions on local artists is too slight to provide a strong impetus to quality in art. But they serve a worthwhile purpose in being at least a momentary encouragement to a few artists.

ANNUAL COMPETITIONS

Esso Calendar Competition is the most highly publicised of the annual art competitions. It once allowed entries from all of East Africa but the response was so great entries had to be limited to Kenya only. Begun in 1955, the competition today is managed by the Kenya Arts Society who select the board of judges and set up the exhibitions. A dozen prizes are offered, from 50/= to 3000/=. Categories are paintings from primary and inter-

mediate schools, secondary schools, technical and teacher training colleges and open prizes. The grand winner's painting will hang in the Nairobi office of Esso's managing director. If suitable it will also be reproduced on 11,000 Esso calendars. Some past grand winners have been Alan C. Chappell, Luis Mbughuni, Mary Kreuger, Eli Kyeyune, Mrs. B. Rabaglino and Ignatius Sserulyo.

African Arts Magazine Competition Each year a competition is announced in *African Arts* magazine, a unique and excellent publication from the African Studies Centre at the University of California in Los Angeles. The USIS and university libraries in East Africa subscribe to *African Arts* but the magazine is not sold on local news-stands or in bookstores. Each competition concentrates on one aspect of African art: painting, sculpture, drama and film, prose and poetry. In 1970 Eli Kyeyune shared the 7000/= prize with three painters from other parts of Africa.

Nehru Painting Competition, organized by the Indian High Commission in Nairobi and Dar es Salaam, commemorates the birthday of Jawaharlal Nehru. Prizes are given to school pupils under 5 years, 5–8 years, 9–12 years and 13–16 years. An adult prize is also given. The competition was started in 1968.

ONCE ONLY COMPETITIONS

Olympic Games Competition A poster competition was held all over Africa before the 1972 Olympic Games in Munich. Winners were selected from each participating country and the posters they designed were used to advertise the Olympic Games. The first prize for Kenya, 12,000/–, was awarded to Ancent Soi.

Our Lady's Cathedral Competition Professor Cecil Todd, formerly Head of Makerere School of Fine Arts, organized a competition for the windows of Our Lady's Cathedral at Fort Portal in Uganda. Godfrey Makonzie won with his "Uganda Martyrs". He executed the windows with technical

assistance from Brother Joseph at the Nsambya stained-glass studio in Kampala.

St. Francis Chapel Competition The Reverend D. A. Payne, Chaplain of the St. Francis Chapel at Makerere University, arranged a competition for the front exterior wall of the chapel. He offered an honorarium and all expenses in erecting the winning work of art. Jonathan Kingdon won with his mosaic "St. Francis' Canticle of the Sun".

University College Dar es Salaam Competition In 1966 a sculpture competition was held at the University College, Dar es Salaam, sponsored by Karimjee Charitable Trust and architects Norman and Dawbarn. Competitors submitted sketches, and the three finalists were awarded 2000/= each and asked to build scale models. George Kakooza's winning sculpture now stands outside the main library on the University campus.

Jean P. Gault, Mural. Photo Harald Nickelsen

Art on Public Display

In cities, public buildings from banks to churches often display murals, mosaics, paintings or sculpture. In Uganda, where many such works are in evidence, artists have often donated their time and contributed their own materials. Recently artists have been paid for commissions. The Head of Makerere School of Fine Arts encouraged local businesses to pass commissions to art school students. He also proposed to the Kampala City Council that they require contractors of large buildings to allot some moneys towards art commissions. In Kenya, hotels and offices often display commissioned art works. Competitions for such jobs do not yet exist and usually go to well-known foreign artists working in Kenya; local artists are often overlooked. In Tanzania there is far less art activity of the sort found in Kenya and Uganda, and fewer commissions in evidence. Once a work of art is permanently installed it is easily overlooked. This list points out some of these art works and gives credit where due.

KENYA

Fort Hall
Fort Hall Memorial Cathedral, murals, Njau
Gatundu
President's home, portrait of Kenyatta, Ng'ethe
Gedi
Ocean Sports Hotel, paintings, Ian Pritchard
Homa Bay
St. Paul's Cathedral, stained-glass windows and wall reliefs, Kakooza
Kapsabet
Karbui Church, leaded lights, Brother Joseph
Kikuyu Town
Alliance High School, stained-glass windows, Kingdon
Kisii Town
Jamhuri Gardens, sculpture, Ong'esa
Kisii Church, stained-glass windows, Kakooza
Nyabururu Mission, Bishop's house, stained-glass windows, Brother Joseph
Malindi
Watamu Beach Hotel, painting, Waite

Masai Mara Game Reserve
Keekorok Lodge, woodcuts, Sanders
Murang'a
Cathedral of the Martyrs, mural, Njau
Nairobi
Air Madagascar, mural, Pierre Gault
All Saints Cathedral reliefs, stations of the cross, Kakooza
Boulevard Hotel, murals, Omondi, Irene Shapira
Consolata Church, stained-glass windows, Franca Ghitti
I.B.M. offices, mural, Michael Adams
Kenyatta Conference Centre, painting, Johnson
Marshalls (E.A.) Ltd., North Branch, mural, Albert Mulembo
Mayfair Hotel, mural, Nani Croze
Nairobi Embakasi Airport, mural, Cajie Fernandes
Parliament, stained-glass windows, Kingdon; sculpture, Michael Croyden; tapestries, East Africa Women's League; painting, Ng'ethe
Ford Foundation, paintings, Adams
Hilton Hotel, mural Waite; pendant (1st floor), Siska Pitt
Marino's Restaurant, mural, Ghitti
New Stanley Hotel, mural, Michael Adams; paintings, Kyeyune, Rocco, Waite, Sanders
Oasis Club, mural, Nani Croze
St. Austin's Church, stained-glass windows, Brother Joseph
State House, mural, Anderson
University of Nairobi, fountain, Frank Foit
Ruaraka
Safari Parks Hotel, fountain, Maloba
Uaso Nyiro
Samburu Lodge, linocuts, Sanders

TANZANIA

Dar es Salaam
Independence Monument, "Myrander"
Institute of Adult Education, painting, Abshehe
Mnazi Mmoja Hospital, sculpture, anonymous
National Bank of Tanzania, mosaic, Njau
University of Dar es Salaam, sculpture, Kakooza
National Arts of Tanzania Gallery, bust of Nyerere, Sweverta

Kigombe

"The Painted Village", murals, Ali and Maya Panga

Masasi

Rondo Chapel, stained-glass windows, Kingdon

Tanga

Tanga Secondary School, paintings, Jengo

UGANDA

Fort Portal

Our Lady's Cathedral, stained-glass windows, Makonzi

Ggaba

Ggaba National Seminary, stained-glass windows, stations of the cross, Todd

Jinja

Jinja Hospital, mural, Norbert Kaggwa

Town Hall, sculpture, Maloba

Kakindu

Kakindu Church, mural, Ntiro

Kampala

Bank of India, frieze, Maloba; mosaic, Todd

Bank of Uganda, obelisque, frieze, Todd

Buganda Kingdom Parliament, mosaic, John F. Kisaka

Central Post Office, mosaic, J. H. Francis

City Council, emblems, Todd

Grand Hotel, ceramic façade, Francis

House of Assembly, relief, Kakooza

Independence Monument, Uhuru Square, Maloba

International Hotel, mural, Adams

Kyambogo National Teachers College, sculpture, Kakooza

Lubaga Cathedral, sculpture, Nnaggenda

Mpala building, mosaic, Kakooza

National Development Bank, sculpture, Martin Gindo

Publicity Services Ltd., mural, Adams

Sisters Convent, Mbuya, stained-glass windows, Brother Joseph

Uganda Banquet Hall, sculpture, Maloba

Uganda Boy Scout's Association, sculpture, Maloba

Uganda Coffee Marketing Board, Ssengendo

Uganda Electricity Board, Ssengendo, Musango

Uganda Growers Cooperative Society, sculpture, Maloba

Uganda Museum, sculptures, Maloba; painting, Adams

Uganda National Theatre, sculptures, Nnaggenda

Uganda Prisons Department, paintings, Sserulyo

Uganda Teachers Association, sculpture, frieze, Sempangi; mural, Makonzi

Shimoni Teachers Training College, sculpture, Brother Anthony Kyemwa

Makerere University

Library, sculpture, Karuga, Ssengendo; mural, Sserulyo, Makonzi

Livingstone Hall, painting, Kareithi

Mary Stuart Hall, paintings, Abdallah, Musoke, Dorothy Sekadda; ceramic decoration, Francis; mural Sserulyo

Mitchell Hall, murals, Kingdon, Sempangi, Makonzi

Mosque, mural, Darwish

Mulago Hill Hospital, mosaic, Todd

New Hall, mural, Senyagwa

Northcote Hall, mural, lunettes, Ntiro; paintings, Sserulyo, Ntiro

St. Agustine's Chapel, stained-glass windows, Brother Joseph, Todd

St. Francis Chapel, mosaic, lunettes, pulpit, Kingdon; baptismal font, Maloba; mural, Njau; sculpture, Sempangi; altar, Bruce Kent and students; tryptich, Adams; ceiling, Kingdon, Sserulyo, Peter Binaka

University Hall, paintings, Wilson Likenga

Zoology Building, mosaic, Todd

Kisubi

Mount St. Teresa, sculpture, Brother Anthony

Lira

Lira Cathedral, stained-glass, Brother Joseph

Masaka

Kitovu Cathedral, painting, Musango

Mukono

Theological College, sculpture, Kakooza

Masulita

Masulita Secondary School, painting, Maloba

Nnamugongo

Catholic Church, shrine to Uganda Martyrs, anon.

Appendices

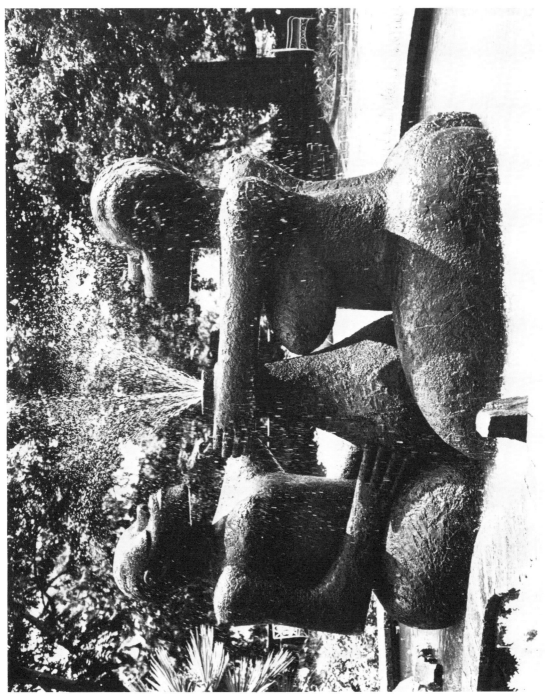

Gregory Maloba, "Metamorphosis". Photo Richard E. Beatty

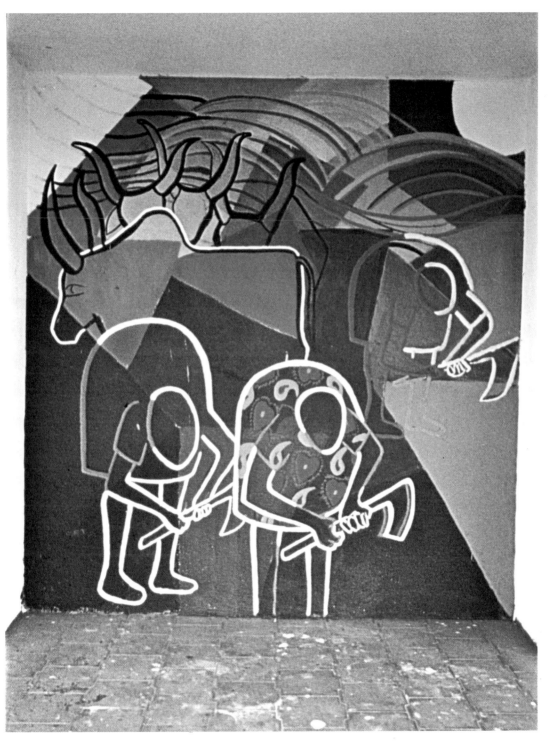

Kenyatta College Mural, "Women Working"

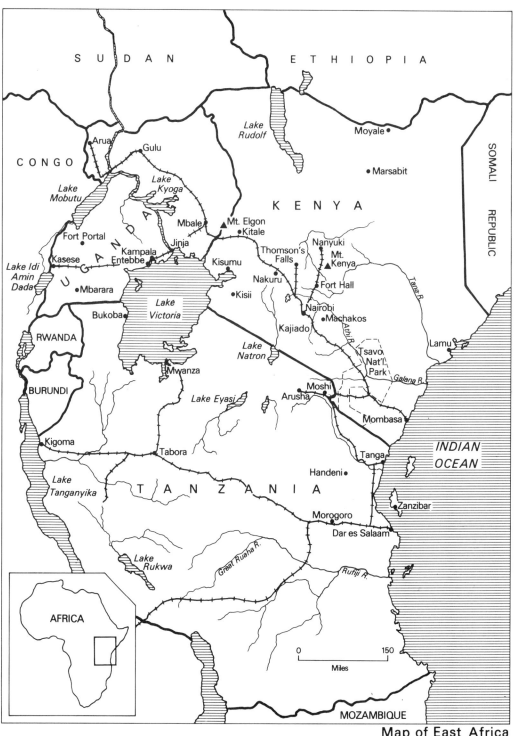

SUDAN

ETHIOPIA

CONGO

SOMALI REPUBLIC

Arua

Gulu

Lake Rudolf

Moyale

Marsabit

Lake Mobutu

Lake Kyoga

KENYA

Fort Portal

Mbale

Mt. Elgon

Kitale

Nanyuki

Kasese

Kampala

Entebbe

Jinja

Kisumu

Thomson's Falls

Mt. Kenya

UGANDA

Mbarara

Nakuru

Fort Hall

Lake Idi Amin Dada

Bukoba

Lake Victoria

Kisii

Nairobi

Machakos

Tana R.

RWANDA

Kajiado

Lamu

Lake Natron

Tsavo Nat'l. Park

BURUNDI

Mwanza

Lake Eyasi

Arusha

Moshi

Galana R.

Atbi R.

Mombasa

Kigoma

Tabora

Tanga

INDIAN OCEAN

Lake Tanganyika

TANZANIA

Handeni

Zanzibar

Lake Rukwa

Great Ruaha R.

Morogoro

Dar es Salaam

AFRICA

Rufiji R.

MOZAMBIQUE

0 150

Miles

Map of East Africa

Directory of Art Institutions in East Africa

African Heritage, Ltd., Box 41730, Kenyatta Ave., Nairobi

Bomas of Kenya, Ltd., Langata Road, Nairobi

Cottage Crafts, Box 45009, Phoenix Arcade, Standard St., Nairobi

Creative Art Centre, Box 6738, Oshwal House, Tom Mboya Street, Nairobi. Tel: Nairobi 20995

East Africa Wild Life Society Gallery, Box 30614, Hilton Hotel mezzanine, Mama Ngina Road, Nairobi. Tel: Nairobi 29751

Esso Calendar Competition, c/o Kenya Arts Society, Box 40392, Nairobi. Tel: Nairobi 25891

Fort Jesus, Box 82412, Nkrumah Road, Mombasa. Tel: Mombasa 25209

Gallery Watatu, Box 21130, Standard Street, Nairobi. Tel: Nairobi 28737

Kamba Carvings, Quarry Road, Pumwani, Nairobi

Kamba Carvings, Tudor Creek, Port Reitz Road, Mombasa

Kamba Carvings, Wamunyu, Machakos

Karibu Gallery, Vasco da Gama Street, Mombasa

Kenya Arts Society, Box 40392, Nairobi. Tel: Nairobi 25891

Kenya Museum Society, Box 40658, National Museum, Ainsworth Hill, Nairobi. Tel: Nairobi 20141, Ext. 17

Kenya National Art Foundation, c/o C. M. P. Martin, Box 15510, Nairobi (Mbagathi). Tel: Langata 893

Kenyatta College Art Department, Box 3844, Thika Road, Nairobi. Tel: Templar 356

Kikenni Crafts, c/o V. Cowie, Box 40505, Nairobi. Tel: Langata 210

Kisii Soapstone Products, Box 316, Kisii, Kenya

Lamu Museum, Box 48, Lamu. Tel: Lamu 42

Maendeleo ya Wanawake, Box 4412, Muindi Mbingu Street, Nairobi. Tel: Nairobi 22095

Maridadi Fabrics, Box 12935, Munyeme Street, Pumwani, Nairobi. Tel: Nairobi 23306

Masai artists, c/o The Principal, Isenya Centre, Kajiado Township

Masai Shops, Magadi Road, Nairobi

Masai Shops, Namanga, Athi River

Nairobi Group, c/o E. Mann, A.H.I.T.I., P.O. Kabete, Nairobi. Tel: Nairobi 22564

National Museum of Kenya, Box 658, Ainsworth Hill, Nairobi. Tel: Nairobi 20141

Ngubi Maendeleo, Naivasha Road, Nairobi

Paa-ya-Paa Gallery, Box 9646, Sadler Lane, Nairobi. Tel: Nairobi 26755

Prison Industries, Box 30175, Langata Road, Nairobi. Tel: Nairobi 25929

Skanda's Wood Workshop, c/o Lamu Museum, Box 48, Lamu. Tel: Lamu 42

Studio Arts Co. Ltd., Box 45351, Standard Street, Nairobi. Tel: Nairobi 27674

Studio Sanaa, Box 83093, Government Square, Mombasa

The Tryon Gallery, Ltd., Box 74004, International Life House, Queensway, Nairobi

University of Nairobi, Department of Fine Art, Box 30197, Ghandi Wing, College Road, Nairobi. Tel: Nairobi 66008

Vocational Rehabilitation Centre, Kenya Ministry of Cooperatives and Social Services, Department of Community Development and Social Services, Division of Vocational Rehabilitation, Box 30276, Nairobi; Maziras Centre, Mombasa; Rehabilitation Centre, M'bagathi Road, Nairobi

Waa, The Bright Spot, Uchumi House, near Nairobi Cinema, Nairobi

Western Kenya Museum, Box 843, Kitale

Y'Crafts Shop, Uchumi House, near Nairobi Cinema, Nairobi

YMCA Crafts Training Centre, Box 30330,

Shauri Moyo, Nairobi. Tel: Nairobi 559510, 558383

YWCA, Box 40710, Beecher House, Kirk Road, Nairobi. Tel: Nairobi 20096

TANZANIA

College of National Education, Chang'ombe

Friendship Textile Mill, Box 20842, Dar es Salaam. Tel: Dar es Salaam 53021

Kibo Art Gallery, Box 798, Marangu Village, Moshi, Tanzania

Makonde Carvings, N.A.T. Gallery, Box 9363, Azikiwe and Independence Avenue, Dar es Salaam. Tel: Dar es Salaam 25113

Makonde Carvings, The Village Museum, Box 511, Bagamoyo Road, Dar es Salaam

Ministry of National Culture and Sports, Box 9121, Dar es Salaam. Tel: Dar es Salaam 27721, 26801

Mwariko's Art Gallery, Box 832, 56 Mafuta Street, Moshi. Tel: Moshi 2464

National Arts of Tanzania Gallery, Box 9363, I.P.S. Building, Azikiwe and Independence Avenue, Dar es Salaam. Tel: Dar es Salaam 25113

National Arts of Tanzania Gallery, Box 300, Arusha, Tanzania

National Development Corporation of Tanzania, Box 2669, Dar es Salaam. Tel: Dar es Salaam 26271

National Museum of Tanzania, Box 511, City Drive, Dar es Salaam. Tel: Dar es Salaam 22160

National Textile Industries Corp., Ltd., Box 9211, Dar es Salaam. Tel: Dar es Salaam 23314

Sanaa Zetu: African Arts of the '70s, Box 798, Kibo Arcade, KNCU Building, Moshi. Tel: Moshi 2592

Society of East African Artists, Ministry of Education, National Culture and Antiquities Division, Box 9121, Dar es Salaam. Tel: Dar es Salaam 21006

Sukuma Museum, Box 76, Rwangasore Street, Mwanza. Tel: Mwanza 2155

Tanzania Arts Society, Ministry of Education, National Culture and Antiquities Division,
Box 9121, Dar es Salaam. Tel: Dar es Salaam 21006

Tanzania Crafts Council, Ministry of Education, National Culture and Antiquities Division, Box 9121, Dar es Salaam. Tel: Dar es Salaam 21006

Tausi Handicrafts Shop, Dar es Salaam

Umoja wa Wanawake wa Tanzania, Box 209, Mkoa wa Pwani, Arnautoglu Community Centre, Dar es Salaam. Tel: Dar es Salaam 25211

University of Dar es Salaam, Institute of Adult Education, Box 20679, Lumumba Street, Dar es Salaam. Tel: Dar es Salaam 25211

YWCA Shop, Box 2086, Azikiwe Street, Dar es Salaam. Tel: Dar es Salaam 63609

UGANDA

Brother Joseph's Stained-Glass Studio, Nsambya Mission, Box 321, Kampala

Busega Pottery, Box 15023, Mubande Road, Kibuye-Kampala

Bwana Centre, Box 174, Kabale. Tel: Kabale 27

Gulu Centre, Box 70, Gulu. Tel: Gulu 76

Kireka Industrial Rehabilitation Centre, Box 20172, Pope Paul VI Road, Kireka. Tel: Kireka 29

Makerere Art Gallery, Box 7062, Kampala. Tel: Kampala 42474

Makerere School of Fine Arts, Box 7062, Kampala. Tel: Kampala 42474

Masaka Cloth Printing Factory, Box 183, Masaka. Tel: Masaka 2048

Mbale Centre, Box 970, 47 Kumi Road, Mbale. Tel: 2730

Namanve Pottery, Box 1103, Jinja Road, Kireka. Tel: Kireka 7

Nommo Gallery, Box 6643, 4 Victoria Avenue, Kampala. Tel: Kampala 54251

Ruti Centre, Box 6, Mbarara. Tel: Mbarara 20

Uganda Arts Club, Box 1486, Kampala

Uganda Crafts, Box 3479, Kampala

Uganda Ministry of Culture and Community Dev., Box 7136, Kampala

Uganda Museum, Box 365, Kira Road, Kampala. Tel: Kampala 41714

Biographies of Artists in East Africa

* Denotes one-man exhibition throughout this section.

Abdullah, Fatmah Shaaban. Born Zanzibar 1939. Attended Women's Teacher Training College, Zanzibar 1959; Makerere School of Fine Arts 1959–64. Tutor of Art and Visual Aids, Nkrumah Teachers' Training College, Zanzibar 1964–70; Assistant Principal there since 1970. Exhibited Nommo Gallery 1965;* Union Carbide Building, New York 1969; London, Berlin, 1966; West Africa; East Africa. Works displayed in Mary Stuart Hall, Makerere University. Member Tanzania Arts Society. First Class Diploma, Makerere University; Margaret Trowell Prize 1960. In *Contemporary African Monographs Series*, No. 4, East African Institute of Social and Cultural Affairs, Nairobi. Box 949, Zanzibar. Uses brilliant colour in a rich, flamboyant application in painting.

Abshehe, Abdulhamid. Born Tanga, Tanzania 1948. Attended Dar es Salaam Technical College 1966–68. Bank teller, National Bank of Commerce, Dar es Salaam since 1968. Exhibited Tanga Government School 1964; Goethe Institute, Dar es Salaam 1967–68; Union Carbide Building, New York 1969. Works displayed in Institute of Adult Education, Dar es Salaam; Makerere Art Gallery. Member Society of East African Artists. C/o National Bank of Commerce, City Drive Branch, Box 9062, Dar es Salaam. Painter.

Ahmed, Tag el Sir. Born Khartoum, The Sudan 1933. Attended Royal College of Art, School of Engraving, London 1959–62; Faculty of Law, Khartoum University 1962; Sheffield University, School of Architecture 1963–67. Taught Khartoum Technical Institute; Khartoum University; Makerere School of Fine Arts 1968–73; University of Nairobi since 1973. Exhibited Thames Gallery, Windsor; Royal Water Colour Society and RBA Gallery, London; Sudan Fine Arts Association, Khartoum 1960–63; Sudanese Pavilion, New York World's Fair 1964–65; Smithsonian Institute 1966–69; Gallery Watatu, Nairobi 1970.* Silver Medal for Engraving, Royal College of Art; First Prize, "Graven Image" exhibition, RBA Gallery. C/o Department of Fine Art, University of Nairobi, Box 30197, Nairobi. Great facility in several media and styles, sometimes with subtle psychological undertones.

Ajaba, Abdala. Born Mindu Village, Nakapanya, Rovuma Region, Tanzania. To Dar es Salaam 1969. Sculptor.

Alale, Pajume. Born Newala, Tanzania 1934. Learned to carve in 1944. Sisal cutter until 1955. Freelance artist, Bokko Village, Dar es Salaam since 1955. Helped set prices for Makonde

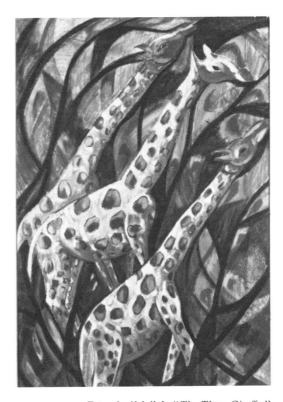

Fatmah Abdallah, "The Three Giraffes"

sculpture for National Development Corporation of Tanzania. Exhibited and toured West Germany and London 1969 (sponsored by Tanzanian National Tourist Board and East African Airlines); Expo '70, Osaka, Japan. Carving Award, Saba-Saba Day, Dar es Salaam 1967. C/o National Development Corporation, Box 2669, Dar es Salaam. Sculptor.

Anderson, Robin. Born Nairobi. Attended Rhodes University College, South Africa; Heatherleys Art School, London. Co-director Gallery Watatu since 1970. Exhibited Commonwealth Institute, London 1953, '67;* Sorsbie Gallery, New Stanley Gallery and Gallery Watatu, Nairobi. Works displayed in Government House, Nairobi; private aircraft of HRH Queen Elizabeth II. Purvis Prize for most outstanding student, Rhodes University. Fellow of Society of Designer-Craftsmen, Great Britain. Box 21130, Nairobi. Angular exaggeration of figures and large areas of colour in batiks. Experiments with new media in painting and sculpture.

Babault, Joanna (Babo). Lives and works in Kenya. Batiks.

Buluma, Mordecai O. Born Samia, Uganda 1936.

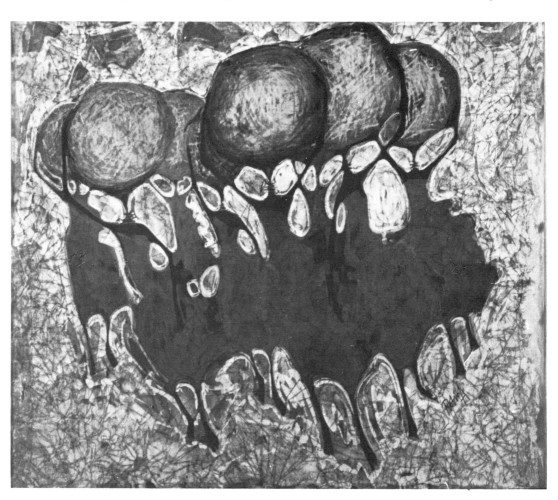

Robin Anderson, Batik

Attended Makerere School of Fine Arts 1956–60; Mount Allison University, New Brunswick, Canada 1960–62 (Commonwealth Scholarship). Toured eastern United States museums with American Association of Museums 1962. Taught Kampala Technical Institute since 1963; Education Officer, Uganda Museum since 1963. Exhibited Smithsonian Institute Travelling Exhibition 1966–68; Union Carbide Building, New York 1969; UNESCO Exhibition of African Art 1961. Member Society of East African Artists. C/o Uganda Technical College, Box 7181, Kampala. Paintings have an easy grace with minimal detail.

Bwanakanga, Bakari. Born Pate Island, Kenya 1935. Self-taught, free-lance artist. Exhibited Lamu Museum 1971. C/o Lamu Museum, Box 48, Lamu, Kenya. Carves wooden trays and plates in precise Swahili designs.

Chego, Paulo. Born Kahuhia Village, Fort Hall, Kenya 1939. Self-taught artist, studies photographs and live animals as models. Completed Standard VIII. Mechanic training, Fort Hall Administration 1955–56; mechanic training, Athi River Cement Factory 1957–58; private driver, Nairobi since 1958. Learned to make pottery in Standard IV. Began making clay figurines in 1971. Sales arranged privately, usually through employer. C/o E. B. Martin, Box 15510, Mbagathi, Nairobi. Terra-cotta figurines of animals in a realistic mode.

Darwish, Ali Hussein. Born Zanzibar 1936. Attended Makerere School of Fine Arts 1957–61; Slade School of Art, University of London (Zanzibar Government Scholarship) 1961–63; School of Oriental and African Studies, University of London 1965–66 (PhD). Taught Makerere School of Fine Arts since 1963. Exhibited Lagos, Nigeria 1961; Lisbon, Portugal 1962; Commonwealth Institute 1962 and RBA Gallery 1963, London; Cologne, Germany 1965; Nommo Gallery, Uganda Museum 1961–71;* Gallery Watatu 1970;* U.S.A. Works displayed Makerere Mosque; Makerere Art Gallery; Nairobi bank.

C/o School of Fine Arts, Makerere University, Box 7062, Kampala. Paints areas of strong colour often washed with swirls of gold script, impressions of clouds, water or birds. Miniature paintings in themes of trees and roads.

Desai, Bhupendra Nathubhai. Born Chikhli, India 1929; to East Africa 1953. Attended Sir J. J. School of Arts, Bombay. Taught Kisarawe and Upanga Primary Schools, Dar es Salaam. Exhibited National Museum of Tanzania, Tanzania Art Society, Human Educational Institute Competition, Nehru Art Competition and Saba-Saba Day Art Competition. Third Prize, Esso Competition 1967, Special Prize 1969. Member Tanzania Art Society. Box 1040, Dar es Salaam. Realistic portraiture.

Diang'a, John. Born Maseno, Kenya 1945. Attended University of Nairobi 1970–72. Clerical officer, Office of the President of Kenya 1969–70. Exhibited Kisumu High School 1964–69; Kisumu Arts Festival 1968; Paa-ya-Paa Gallery 1969;*

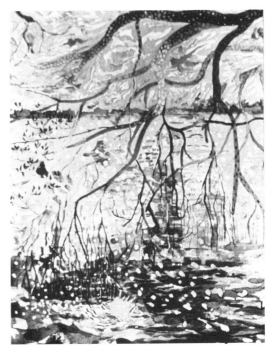

Ali Darwish, "Tree and Pool"

85

Gallery Africa 1970. Member Nairobi Group; Students' Creative Society, President and Editor of Art Department magazine, University of Nairobi. Writing a book about his art. C/o Department of Fine Arts, University of Nairobi, Box 30197, Nairobi. Small terra-cotta figurines with strong sculptural weight, exaggeration of features for symbolic effect.

Fennessy, Rena Margaret. Born Southampton, England. Commercial artist, Nairobi 1956–64. Exhibited New Stanley Gallery 1967; San Antonio, Texas, 1969; Nairobi Galleries, Hilton Hotel, 1970; Tryon Gallery, London, 1974. Illustrated *Field Guide to the Birds of East and Central Africa* and *Field Guide to the National Parks of East Africa*, J. G. Williams; M. M. Aldridge's children's books; *Birds of Africa*, Barbara Kimenye and J. G. Williams; stamps for Kenya, Tanzania, Uganda; Shell Guides to East Africa. Box 2389, Nairobi. Realistic paintings of animals with individual flair.

Gastellier, Jany. Attended Academy of Art, Liege, Belgium. Works in Malindi, Kenya. Jewellery design.

Githinji, Paul. Born Bogoine village, Mathera Division, Nyeri, Kenya 1944. Completed Standard III. Employed at a dairy farm; Nairobi Game Department; private homes. Began making clay figurines in 1971 in partnership with Paulo Chege. C/o Robert Glen, Box 691, Nairobi. Self-taught, studies photographs and live animals to perfect terra-cotta sculptures.

Glen, Robert. Born Kenya 1940. Studied taxidermy, National Museum, Nairobi, with John G. Williams; apprenticed 3 years with Jonas Bros. Taxidermy, Denver, Colorado. Participated in ornithological survey trip, Los Angeles Museum, in Uganda. Studied art and anatomy, night school, Denver. Taxidermist, Zimmerman's, Nairobi 1961–65; collected artifacts in East Africa, West Africa,

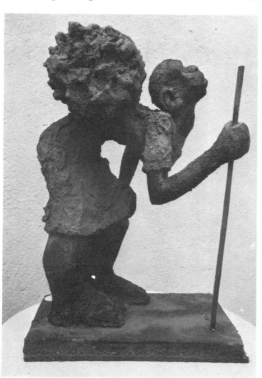

John Diang'a. Photo Harald Nickelsen

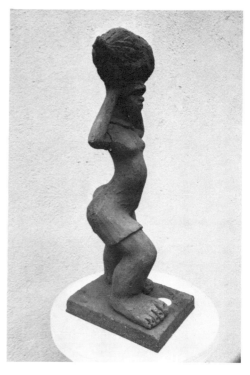

John Diang'a. Photo Harald Nickelsen

Madagascar for American and Canadian Museums 1965–70. Cast a series of bronzes of African wild-life and East African tribes at Meridian Bronze Foundry, Peckham, London. Exhibited Game Conservation Conference, San Antonio, Texas 1971. Works displayed Tryon Gallery, London. Box 691, Nairobi. Bronze sculptures of wildlife and East African tribes strictly adhere to ana-tomical accuracy.

Halake, Abdulahi. Born Moyale, Kenya 1945. To Nairobi 1968. Herdsman and artist since 1968. Exhibited Gallery Watatu 1971. C/o Gallery Watatu, Box 21130, Nairobi. Wood sculptures have a rounded harmony, sometimes spots of white paint for accent.

Hirst, Terry H. Head, Kenyatta College Art Dept. 1967–70; lecturer, University of Nairobi Dept. of Fine Art since 1970. P.O. Box 30197, Nairobi. Painter.

Jengo, Elias. Born Tanga, Tanzania 1936. At-tended Makerere School of Fine Arts and Educa-tion 1959–63; Kent State University, Ohio 1964–65 (USAID Fellowship). Taught Tabora Secondary School, Tanzania 1963; Teachers' College, Dar es Salaam 1964, 1965–68; Dept. of Education, University of Dar es Salaam since 1969. Exhibited Independence Day 1961 and Goethe Institute 1968, Dar es Salaam; Society for African Culture, Munich 1968; Union Carbide Building, New York 1969; National Museum, Dar es Salaam 1966, '69. Works displayed Uni-versity of Waterloo, Canada (Gift of Tanzanian Ministry of Education); Tanga Secondary School; International Telephone and Telegraph Building, New York. First and Second Prizes, Saba-Saba Day Competition, Dar es Salaam 1967. Illustrated biology book, educational pamphlets, *Education of Girls in Tanzania;* in *Newsweek*, February 1971. Vice-President Tanzania Arts Society; member Society of East African Artists. C/o University of

Rena Fennessy. Photo Harald Nickelsen

Dar es Salaam, Department of Education, Box 35091. Specialist in illustrations in romantic realist mode.

Johnson, Harper. Works displayed Kenyatta Conference Centre, Nairobi. Box 41737, Nairobi. Painter.

Kakooza, George Patrick Kagaba. Born Uganda 1936. Attended Makerere School of Fine Arts 1958–62; Ecole Nationale Superieure des Beaux Arts de Paris (French Government scholarship), Academie de Feu, Sorbonne, 1963–64. Taught Namagunga Girls Secondary School 1962–63; Makerere School of Fine Arts since 1965. Exhibited Independence Day and National Museum, Dar es Salaam 1961; Commonwealth Institute, London 1962; Marseilles 1964; Galerie Ramond Dancan 1964★ and Annual Ecole des Beaux Arts Exhibits, Paris 1963, '64; Nommo Gallery 1965,★ '68; Alliance Francaise, Kampala 1970.★

Works displayed St. Paul's Cathedral, Homa Bay, Kenya; University of Dar es Salaam; Kampala Primary School, House of Assembly, Mpala Building, Kyambogo Library, Kampala; Mukono Theological College, Uganda; Uganda Pavilion, Expo '70, Osaka, Japan. In *African Music Society Journal; Traditional Dances of Uganda.* C/o Department of Fine Art, Makerere University, Box 7062, Kampala. Large, welded-metal sculptures in stark modernity; paintings similar.

Kalyamagua, Augustine. Born *c.* 1900 near Kampala. A farmer and self-taught artist. Lives, works and exhibits at his home on Entebbe-Kampala Road. Uses terra-cotta, papier-mâché, wood and wood knots in stick figures or carvings. Some images are consumed, with representational notations for eyes, mouth and limbs.

Kareithi, Peterson Munuhe. Born Kikuyu, Kenya 1932. Attended Kagumu Teachers' Training

Augustine Kalyamagua

College, Nyeri, Kenya 1952–53; Makerere School of Fine Arts and Education 1959–63; Kent State University, Ohio (I.I.E. grant from USAID) 1964–65. Taught Kaguma Teachers Training College 1965–66; Inspector of Art Education, Kenya 1966–70; Senior Education Officer since 1970. Exhibited Kent State University 1964; Kraimu Centre, Cleveland, Ohio, 1965; Paa-ya-Paa Gallery 1967; Kenya Cultural Centre 1968. Works displayed Presbyterian Church of the Covenant, Boston; Livingstone Hall, Makerere University. Chairman Kenya Society for Art Education; Secretary Kenya National Art Foundation 1972. Author *Let the Child Create*, Equatorial Publishers, Nairobi; research on the Kamba carving industry since 1972. C/o Ministry of Education, Box 30040, Nairobi. Painter, potter.

Karuga, Rosemary Namuli. Born Kenya 1928. Attended Makerere School of Fine Arts 1950–52. Taught Gakuka Primary School, Kiambu, Kenya; Ruera Primary School, Ruiru, Kenya since 1954. Exhibited Kenya Arts Society; Gallery Africa; Paa-ya-Paa 1965, '67; New Stanley Gallery 1965–67; Kimbo Art Gallery 1965. Works displayed Makerere Art Gallery, London, U.S.A. (private collections). Assistant Secretary, Society of East African Artists. In *Topic* magazine. C/o Ruera Primary School, Box 46, Ruiru, Kenya. Great facility in realistic terra-cotta figurines.

Katarikawe, Jak. Born near Kabale, Kigezi, Uganda 1940. Taxi driver and vegetable wholesaler until 1965; free-lance artist since 1965. Exhibited Nommo Gallery 1966,* '70; Adult Education Centre, Dar es Salaam; New Stanley Gallery 1967–68; Union Carbide Building, New York 1969; Paa-ya-Paa Gallery 1968; Switzerland 1971. Member Society of East African Artists. *African Arts* magazine prize 1971. In *Topic* magazine, No. 47; *African Arts*, Winter 1971; 7-minute film of paintings and artists in Uganda (c/o Mrs. E. Keeble, Makerere University, Box 7062, Kampala). C/o Professor David Cook, Department of English, Makerere University, Box 7062, Kampala. A conscious and effective

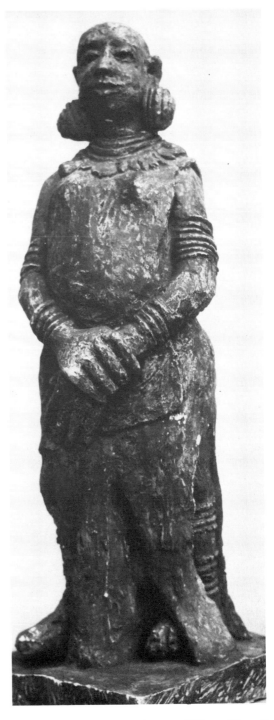

Rosemary Karuga, "Kikuyu Woman"

89

adult-child mode in painting, using bright areas of intense colour and humorous naïveté in design and perspective.

Katembo, Joseph. Born Mutata, Kibu Province, The Congo 1938; to Kenya 1963. Attended Ecole de Selice, Kinshasa. Free-lance artist. Exhibited New Stanley Gallery 1966;* Uganda Museum 1967; Art Centre Foundation, Lusaka, Zambia 1968, '70. Stanleyville Art Competition award 1957. Rural scenes in a romantic-realist mode.

Kiarii, Nganga Andrew. Born Limuru, Kenya 1937. Attended Kilimambogo Teacher's Training College, Thika, Kenya 1957–58, '60; Correspondence courses 1967–69; University of Nairobi since 1970. Taught, headmaster, Nderu Primary School, Limuru, Kenya 1961–65; taught, deputy headmaster, St. Michaels Primary School, Nairobi 1966–68; headmaster, Thing'io Harambee Secondary School, Kiambu, Kenya 1969–70. Exhibited Gallery Africa 1969–70. Works displayed Ideal

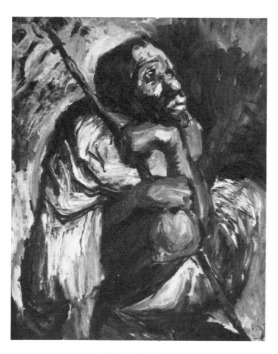

Jonathan Kingdon, "Batwa Beggar"

Nursing Home and Watani Hostel, Nairobi; Chicago. In Shell Calendar 1971. C/o Embakasi Airport, Box 19294, Nairobi. Brusque images in hard, porous stone. Sculptor, painter.

Kidiga, Timothy. Born Western Kenya 1944. Attended Keys College, Nairobi 1963. Apprenticed to Elimo Njau, Kibo Art Gallery 1968; assistant, Paa-ya-Paa Gallery since 1967; guitarist, Uguzi Boys Band, Nairobi. Exhibited Paa-ya-Paa Gallery 1971. C/o Paa-ya-Paa Gallery, Box 9646, Nairobi. Rough-hewn stone carvings; animal motifs in batiks.

Kingdon, Jonathan. Born Tabora, Tanganyika 1935. Attended Ruskin School, Oxford 1952–56; Royal College of Art, London 1956–59. Taught Working Men's College, London 1958–60; Makerere School of Fine Arts since 1960. Exhibited Islington, England 1959;* Uganda Museum 1963;* Sorsbie Gallery 1963;* Nommo Gallery 1966;* Gallery Watatu 1970.* Works displayed St. Francis Chapel, Makerere University; Rondo Seminary Chapel, Masasi, Tanzania; Nairobi Parliament; Chidya Secondary School, Masasi; Alliance High School, Kikuyu, Kenya; Agricultural Development Corporation, Nairobi; Bukoba Cathedral, Tanzania. Vice-President, Uganda Society; corresponding member International Congress of Graphic Designers; Chairman of the Board, Uganda Museum. Illustrations and covers for primers "Abantu abaakolera Ensi yonna", Eagle Press Luganda Series; *Transition* magazine; African Studies Programme publications; author and illustrator *East African Mammals: An Atlas of Evolution in Africa*. Directed exhibitions in England and East Africa; founded and organized Young Commonwealth Artists, London 1958; initiated and edited *Roho* magazine, Makerere University, 1960–62; produced "The Scar", Uganda Drama Festival 1960; wrote and produced "To Build a Road", Radio Uganda 1961; prepared six TV programmes on art for secondary schools in Uganda 1965. C/o Department of Fine Arts, Makerere University, Box 7062, Kampala. Sophisticated command of several

modes and media; cogent attention to detail in fine line drawings.

Kiwanuka, Andrew. Born Uganda 1936. Attended Makerere School of Fine Arts and Education 1957–63. Artist for Ministry of Information, Kampala. Exhibited Independence Day, Dar es Salaam 1961. C/o Ministry of Information, Box 7142, Kampala. Painter, printmaker.

Kiyame, Israel Hadoram. Born 1959. Attended Kibasila Secondary School. Awarded grant from Ministry of National Education and Ministry of Regional Administration and Rural Development (Maendeleo) to study art. Fourth prize, Department of Botany competition, University of Dar es Salaam 1970; third prize, Nehru Competition adult group. Exhibited Metropolitan International Arts Competition, U.S.A. and received 105/=. Painter.

Kyemwa, Brother Anthony. Born Uganda 1930. Attended St. Mary's College, Kisubi, Uganda 1946–51; Makerere School of Fine Arts 1954–59; Indiana University, U.S.A. 1966–67. Taught St. Leo's College, Virika, Uganda 1959–60; St. Henry's College, Kitovu, Uganda 1960–61; Assistant Headmaster, St. Mary's College, Kisubi 1961–65; Headmaster there since 1967. Exhibited Independence Day, Dar es Salaam 1961; Makerere University 1962; Nairobi 1964; Nommo Gallery 1969; National Gallery, London. Works displayed Makerere Art Gallery; Shimoni Teachers Training College, Kampala; Mt. St. Theresa, Kisubi. Member Uganda Arts Club. In *Uganda*, historical publication. Box 26, Kisubi, Uganda. Architectural massiveness in hard stone sculpture; painter.

Kyeyune, Eli Nathan. Born Busi Island, Lake Victoria, Uganda 1936. Attended Makerere School of Fine Arts 1959–62. Assistant, Chemchemi Cultural Centre 1963; research in Uganda ethnology, Department of History, Makerere University since 1972. Free-lance artist. Exhibited Uganda Museum 1964;★ National Museum, Dar es Salaam 1964; Chemchemi Cultural Centre 1964;★ Commonwealth Institute, London 1964–66; Nommo Gallery 1965;★ Saba-Saba Day, Dar es Salaam 1966; USIS Auditorium, Kampala 1971.★ Works displayed Uganda Embassies abroad; National and Grindlays Bank boardroom, London; All-African Conference of Churches, Training Centre for Mass Communication; New Stanley Hotel, Tate Room, Nairobi. Esso Calendar competition prize 1961, '62, '63, '70; first prize, Arusha Rotary Club 1967; *African Arts* magazine prize 1970. Wrote and produced one-act play, Uganda National Theatre 1963; novel on Uganda mythology and culture, East African Publishing House, Nairobi; covers, African Writers Series, Heinemann Press, since 1964; art reviews, *Sunday Nation*, Nairobi. C/o Pio Zirimu, Department of Literature, Makerere University, Box 7062, Kampala. Sensitive depth of feeling in painting, recently specializing in portraiture.

Lasz, Philip Charles. Born Rethy, The Congo

Louis Mbughuni, "Portrait"

1933. Attended Wheaton College, Illinois 1952–56. Art Director, Kesho Publications, Kijabe, Kenya 1961–71; Art Director, Ken Anderson Films, Winona Lake, Indiana 1971–72. Illustrations and layout, Africa Inland Mission publications. Exhibited Gallery Africa 1970; Houston Galleries, Texas, 1970; Gamecoin Convention, San Antonio, Texas 1971. In *Africana* magazine, Nairobi. P.O. Kijabe, Kenya. Serene animal paintings, realistic, gracefully rendered.

Linda, January. Exhibited National Museum, Dar es Salaam 1972. Pupil of Tingatinga, Msasani Workshop, Dar es Salaam.

Lyimo, John Elisante. Born Marangu-Moshi, Tanzania 1940. Attended Ifunda Trade School, Iringa, Tanzania 1956–57; Handicraft Teachers College, Tanga, Tanzania 1958–59; Institute of Adult Education, Moshi, Tanzania 1967. Taught

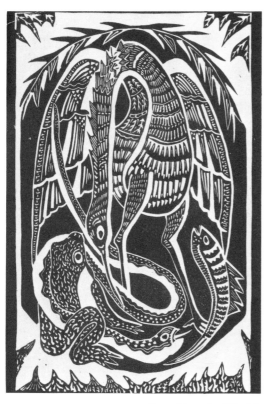

Betty Manyolo, "Fable"

Kidia Upper Primary School, Moshi, since 1965. Exhibited Institute of Adult Education, Dar es Salaam 1967; Nommo Gallery 1968; New Stanley Gallery 1968; Bensheim-Munich 1969; Union Carbide Building, New York 1969; National Museum, Dar es Salaam 1970. Member Society of East African Artists. C/o Kidia Upper Primary School, Box 317, Moshi, or Marangu Postal Agency, c/o Nganuma Parish, P.O. Kibo, Tanzania. Portraiture in romantic-realistic mode, soft palette.

Makonzi-Lutalo, Godfrey W. S. Born Uganda 1944. Attended Makerere School of Fine Arts 1964–68; Royal College of Art, London, 1968–71. Taught Kira Primary School, Uganda 1962–63; Kololo Senior Secondary School, Uganda 1967–68; Makerere School of Fine Arts since 1970. Research in preventive medicine, Kasangati Hospital, Uganda 1964; radio announcer, Kampala 1965. Exhibited Esso Calendar Competition 1962; Uganda Senior Secondary Schools, YMCA, Kampala 1964; Nommo Gallery 1968.* Works displayed Mitchell Hall, Library, Makerere University; Uganda Teachers Association Building, Kampala; Makerere Art Gallery; Our Lady's Cathedral, Fort Portal, Uganda. Member Association of the Royal College of Art, London. First prize, Kololo Secondary School 1963; first prize, Uganda Schools 1963; first prize, Alligator Competition, East Africa 1964; Margaret Trowell Prize 1966, '68; Silver Medal, Royal College of Art 1971. In *The Kololian; The Pearl of Africa.* C/o Department of Fine Arts, Makerere University, Box 7062, Kampala. Concern for traditions and new techniques in pottery.

Maloba, Gregory Paul. Born Mumias, Kenya 1922. Attended St. Mary's College, Kisubi, Kenya 1940–41; Makerere School of Fine Arts 1941–45; Bath Academy of Art, England 1948–50; Corsham Court, Wiltshire, England; Camberwell School of Arts and Crafts, London 1956–59; Royal College of Art, London 1956–57. Taught Makerere School of Fine Arts 1945–66; Head, University of Nairobi Department of Fine Art since 1966. Exhibited

Imperial Institute, London 1949; British Council, Bristol 1950;★ Sorsbie Gallery 1961; Independence Day, Dar es Salaam 1961; Commonwealth Institute, London 1962; Munich 1965. Works displayed Uganda Museum; Uganda Boy Scout's Association; Bank of India, Kampala; Uganda Independence Monument; Uganda Banquet Hall; Uganda Growers Cooperative Society; St. Francis Chapel, Makerere University; Masulita Secondary School and Jinja Town Hall, Uganda; City Hall, Nairobi; Safari Parks Hotel, Ruaraka, Kenya; Imperial Institute, Commonwealth Institute, London; Uganda Embassies abroad. President Uganda Arts Club 1956–62, '64; member Kenya College of Arms. Attended UNESCO Conference, Ibadan, Nigeria 1959; Conference of Africanists, Dakar 1967; Art-Design Panel, Kenya Institute of Education. Founded Bomas of Kenya, Ltd., 1972, C/o University of Nairobi Department of Fine Arts, Box 30197, Nairobi. Long career in sculpture from realistic busts to angular modernity and recent experimentation in new media.

Manyolo, Estelle Betty. Born Uganda 1938. Attended Makerere School of Fine Arts. Artist, Department of Health, Entebbe, Uganda. Exhibited Smithsonian Institute 1966–68. C/o Sangowawa, Training Division, Inter-American Development Bank, 808 17th Street N.W., Washington, D.C., 20577. Vivacious colours in rural scenes.

Mathews, Terry. Born England, raised in Kenya. Studied in England. Professional hunter thirteen

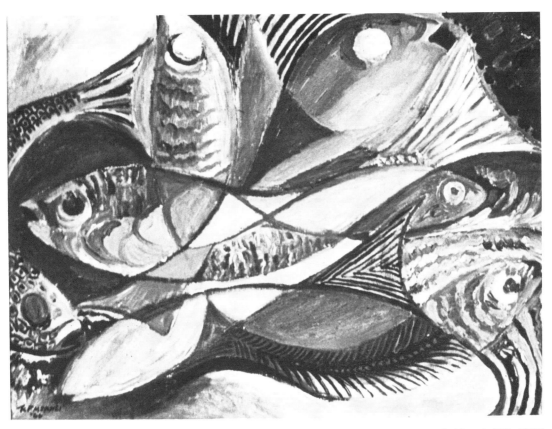

Francis Msangi, "The Fish"

93

Mugalula Mukiibi

years. Owner sculpture factory, Nairobi. Kenya Government commission, "The World Exhibition of Hunting", Hungarian Government, Budapest 1971. Box 47448, Nairobi. Realistic terra-cotta animal heads; reproductions in plastic.

Matti, Severino M. Born Langabu, Uganda 1938. Attended Makerere School of Fine Arts and Education 1963–68, 1971–73. Senior Tutor and Acting Principal, Moroto Teachers Training College, Uganda 1968–71. Exhibited Uganda Museum 1969.★ Works displayed Makerere Art Gallery. Member Uganda Arts Club. Margaret Trowell Award 1967. In *Transition* magazine; illustrated Dr. Foxes *Stories from East African School Children.* C/o Triple Men's Hall, Makerere University, Box 7062, Kampala, or Box 456, Gulu, Uganda. Paintings with patterns of pointillism in crowded, lively scenes, bright colours, charming naïveté in perspective.

Mazinga, Theophilus Makerebete. Born Uganda. Attended Nairobi University; Makerere School of Fine Arts. Taught Bishop's Senior Secondary School, Mukono, Uganda; Makerere College Demonstration School; Tororo Girls Secondary School, Uganda; Department of Education, Makerere University. Exhibited Nommo Gallery 1965, '67, '69, '70; New Stanley Gallery 1965–68; Uganda Museum 1971.★ C/o Department of Education, Makerere University, Box 7062, Kampala. Proficiency in batiks; elongated, angular figures.

Mbughuni, Luis Azaria. Born Vuga, Tanga District, Tanzania 1941. Attended Makerere School of Fine Arts 1963–67; University of Dar es Salaam 1970–74. Promoted Arts and Crafts, Tanzania, for Ministry of Community Development and National Culture 1967–68; Book Production Officer, Ministry of Regional Administration and Rural Development (UNESCO Pilot Project, Mwanza, Tanzania) 1969–70; Tutorial Assistant, Department of Theatre Arts, University of Dar es Salaam since 1970. Exhibited Nommo Gallery 1964, '65, '66; St. Francis Chapel, Makerere

University 1966, '67; Goethe Institute, Dar es Salaam 1968; Tanzania Arts Society 1969; Zambia National Arts Festival, Lusaka 1968; First Pan-African Festival, Algiers 1969; Tanzania Arts and Crafts Show, Germany 1969; Union Carbide Building, New York 1969. Secretary, Tanzania Arts Society and Tanzania Crafts Council. Esso Competition prize 1968. Collected and designed Tanzania exhibit, Expo '70, Osaka, Japan; designed prospectus, Home Education Training Centre; "Uzazio Najira" for Family Planning Unit; various Government and University pamphlets. C/o Theatre Arts Department, University of Dar es Salaam, Box 35091. Recently specializing in pamphlet design and book illustration. Painter.

Moto, Alphonse. Born Buta, Kisangani Province, The Congo 1938. Attended Ecole des Beaux Arts, Brazzaville 1953–55; Ecole des Arts et Metiers, Brussels 1961–63. Travelled in Africa and Europe selling paintings. Free-lance artist. Exhibited Maison Africain, Paris 1961;* Tucson, Arizona; Los Angeles 1967;* National Museum, Dar es Salaam 1968;* City Hall, Nairobi 1971;* other places in the U.S.A., Europe and Africa. Works displayed Papadopolous Hotel, Kisangani, The Congo; Congo National Museum, Kinshasa; National Museum, Brussels. Prolific proficiency in landscape paintings.

Msangi, Albert Taseni. Born Usangi, Pare District, Tanzania 1946. Attended Makerere School of

Francis Musango

95

Fine Arts and Education 1966–71. Taught Uyunga Secondary School, Mbeya, Tanzania 1970–71. Exhibited Lomwe Upper Primary School 1968,★ '61. Works displayed Makerere Art Gallery. Member Society of East African Artists. C/o Uyunga Secondary School, Box 701, Mbeya, Tanzania. Painter, printmaker.

Msangi, K. Francis. Born Usangi, Pare District, Tanzania 1937. Attended Mpwapwa Teachers Training College 1956–57; Makerere School of Fine Arts and Education 1959–64. Head, Art Department, Mpwapwa Teachers Training College 1964–66; Assistant Headmaster and Art Master, Uyunga Secondary School; visiting instructor, Loleza Girls School, Mbeya Secondary School 1967; taught Nairobi University Department of Fine Arts 1968–72; California School of Arts and Crafts, Oakland, teaching and studying since 1973. Exhibited Independence Day, Dar es Salaam 1961; Chemchemi Cultural Centre 1964;★ National Museum, Dar es Salaam 1967;★ University College, Nairobi 1968;★ Union Carbide Building, New York 1969; Intercontinental Hotels, Frankfurt, Dusseldorf, Hanover (sponsored by East African Airways and Hotel Intercontinental) 1970; III Biennale International, Graphics, Krakow 1970; USIS Auditorium, Nairobi 1971;★ Detroit 1974. Margaret Trowell Award 1963; honourable mention, *African Arts* magazine competition 1968. In *African Arts*, Summer, Autumn, 1970; Dictionary of African Biography, 2nd edition 1970 (Certificate of Merit); covers and illustrations for publishers: Heinemann, Oxford University Press, Longman. C/o California School of Arts and Crafts, Oakland, California. Productive in several media, notably graceful line drawings, abstract lithographs and paintings.

Mukiibi Mugalula. Born Kira, Buganda, Uganda 1943. Attended Makerere School of Fine Arts and Education 1962–66. Taught Moroto High School, Uganda; St. Henry's College, Kitovu, Uganda; Makerere Demonstration School; Kitante Hill School, Kampala. Exhibited Nommo Gallery 1967,★ '69,★ '71;★ Paa-ya-Paa Gallery 1968;★

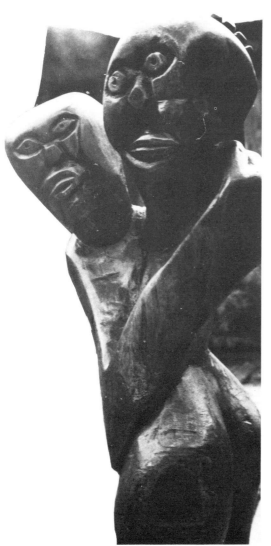

Omari Mwariko

96

Gallery Africa 1970;* Norway (3 cities) 1971;* III Biennale International, Graphics, Krakow 1970. Third prize, Gallery Africa—BBC contest 1971; third prize, Esso competition 1965. Constructing an art centre near Kampala. C/o Kitante Hill Senior Secondary School, Box 7102, Kampala. Paintings of angular, elongated figures, sometimes planes of colour broken into geometrical, cubist shapes. Freer lines in sculpture.

Musango, Francis. Born Nsambya, Uganda 1931. Attended Makerere School of Fine Arts and Education 1954–59. Deputy Principal, Mt. St. Theresa Teachers Training College, Entebbe, Uganda 1959–60; taught Fort Portal, Toro, Uganda 1960–61; Senior Lecturer and Head, Art Department, St. Henry's College, Kitovu, Masaka, Uganda 1961–71; Deputy Principal St. Henry's since 1971; Novitiate, Brothers of Christian Instruction 1952–61. Exhibited Chemchemi Cultural Centre 1962; Nommo Gallery 1963, '65, '66; Paa-ya-Paa Gallery 1964; Kibo Art Gallery 1965; Uganda Museum 1967; Union Carbide Building, New York 1969; Gallery Africa 1971.* Works displayed Kibo Art Gallery, Kitovu Cathedral, Masaka; Uganda Electricity Board, Kampala; Uganda Embassy, Moscow; Makerere Art Gallery. Secretary, Society of East African Artists 1969; active in Chemchemi Cultural Centre, Paa-ya-Paa Gallery, Kibo Art Gallery, Nommo Gallery. In Liturgical Art Magazine. C/o St. Henry's College, Box 64, Masaka, Uganda. Painter, sculptor, textile designer.

Musoke, Therese. Born Uganda 1941. Attended Makerere School of Fine Arts; Royal College of Art, London. Taught Makerere School of Fine Arts. Exhibited Europe; East Africa; Alliance Francaise, Uganda Museum 1964,* National Theatre, Kampala 1969. C/o Makerere School of Fine Arts, Box 7062, Kampala. Lively paintings in clear, bright colours.

Mwangi, Simon. Born Fort Hall, Kenya. Trained YMCA Shauri Moyo Crafts Training Centre. Free-lance artist; worked for Maridadi Fabrics;

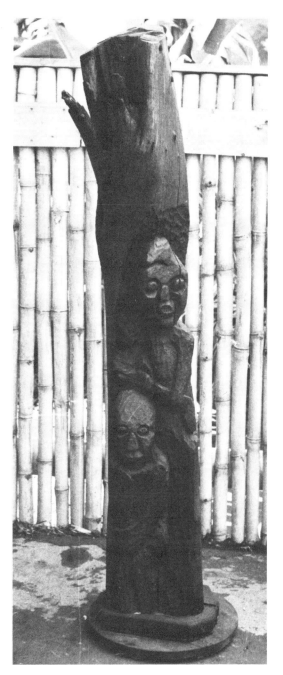

Omari Mwariko

Nairobi Group. Member YMCA Home Industries Team. C/o Maridadi Fabrics, Box 23306, Nairobi, or YMCA Crafts Training Centre, Box 30330, Nairobi. Geometric patterns for fabric designs on silk screen.

Mwaniki, Louis. Born Nyeri, Kenya 1934. Attended Makerere School of Fine Arts and Education 1957–61; Art Academy, Turin, Italy 1961–63; Sir George Williams University, Montreal, Canada 1967–69. Advertising artist, Uganda plantation and manufacturing firm; illustrator, Ph.D. research dissertation on mountain gorilla, 1960–61; taught University of Nairobi 1963–67 and since 1969. Exhibited Rome 1961;* Chemchemi Cultural Centre 1964;* Paa-ya-Paa Gallery 1966;* Sir George Williams University 1969;* Italian Trade and Industry show, Nairobi City Hall 1970;* Gallery Watatu, 1970, '71;* Mestna Galarija, Yugoslavia 1972;* other cities in Africa and abroad. Works displayed Kerugoya Church, Kirinyaga District, Kenya. Member Kenya National Art Foundation. Margaret Trowell Award 1958–59; '60–61; Uganda Trading Corp. prize for painting 1960; first prize National Festival of Tanganyika 1964; second prize Muhjibhai Madhivani Calendar 1960; pre-eminent contributor, Commonwealth Institute 1963. Illustrated "Around Mt. Kenya", Makerere 1960; cover "Comment on Corfield", MKEMSA 1960; inaugural issue *Roho* magazine 1961; "Ode to Mzee", Joseph Kariuki 1964; *Pan African Stories*, Neville Denny 1965. C/o University of Nairobi Department of Fine Arts, Box 30197, Nairobi. Sculpture in cast cement and metal; paintings often satirical and serial; lithographs bold and visceral.

Mwariko, Athumani Omari. Born Handeni, Tanzania 1944. Herdsboy; apprenticed to Elimo

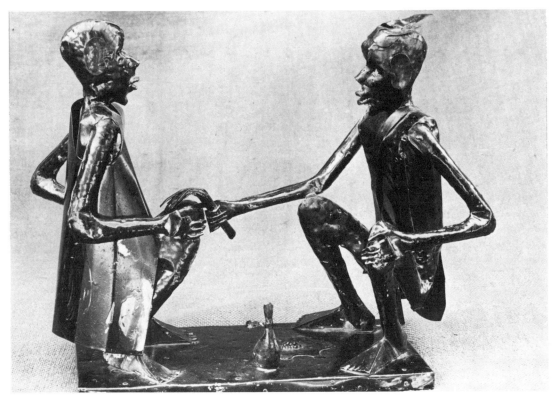

Francis Ndwiga. Photo Richard E. Beatty

98

Njau, Kibo Art Gallery. Director, Mwariko's Art Gallery, Moshi, Tanzania since 1967. Attended Makerere School of Fine Arts. Three-week lecture/demonstration programme, Haystack Mount School of Crafts, Maine, U.S.A. Exhibited Hindu Mandel, Moshi 1965;* National Museum, Kampala 1962; National Museum, Dar es Salaam 1963; Chemchemi Cultural Centre 1964;* Kibo Art Gallery 1965; East African Community, Arusha, Tanzania 1967; Permanent Mission of Tanzania to the United Nations, New York 1968; New Africa Hotel, Dar es Salaam 1969;* Kilimanjaro Hotel, Dar es Salaam 1969; Expo '70, Osaka, Japan; Commonwealth Institute, London 1972. Awarded African Star from England; spear by President Kenyatta at East African Community opening; award from King of Sweden. Formed Association of African Drama, Wandama Village, Handeni. In numerous local publications and newspapers; illustrated for Longmans, East African Literature Bureau. Box 832, Moshi, Tanzania. Painter, innovative sculptures in primitive brusqueness.

Ndumu, Joseph. C/o United Kenya Club, Nairobi. Banana fibre, painting, wood carving.

Ndwiga, Francis. Born Runyenjes, Embu, Kenya 1944. Completed Standard VIII 1962. Worked as solderer, Nairobi; game scout, Nairobi; self-employed purifying and selling solder. Began making tin sculptures 1965. Exhibited Gallery Africa; Homecraft (Kenya) Ltd.; Zebra Craft; Kenya Crafts (all Nairobi). Runyenjes, Embu, or Box 13159, Nairobi. Tin figurines of local scenes.

Ng'ethe, Asaph. Born Kiambu, Kenya 1930. Attended Kagumu Teacher Training College 1949–50; Makerere School of Fine Arts 1951–54. Designed posters for Uganda Ministry of Community Development 1955–57; Chief Artist, East African Literature Bureau since 1964. Exhibited Uganda Museum 1956; Chemchemi Cultural Centre 1963; Saba-Saba Day, Dar es Salaam 1966; Paa-ya-Paa Gallery 1966; New Stanley Gallery 1967. Works displayed President

Kenyatta's home, Gatundu, Kenya; Parliament Building, Nairobi; Kibo Art Gallery; Makerere Art Gallery. Member Society of East African Artists. C/o East African Literature Bureau, Box 30022, Nairobi. Painter specializing in scenes of traditional rural life; uses warm earth tones, realistic-romantic mode.

Ngugi, Kamau. Born Kenya. Three years' schooling. Gardener at Teacher Training College near Thika, Kenya; encouraged by John Kaburu, College Art Master. Exhibited Thailand; Gallery Africa. Works with protégé Simon Mwasa. Sculptures in granitic stone; stolid primitivism boldly expressed.

Nickelsen, Harald Olaf. Born Hamburg 1929. Attended Massachusetts College of Art, Boston 1947–51. Advertising executive, Nairobi 1961–70; freelance journalist since 1970. Exhibited Donovan Maule Theatre, Nairobi 1966–71;*

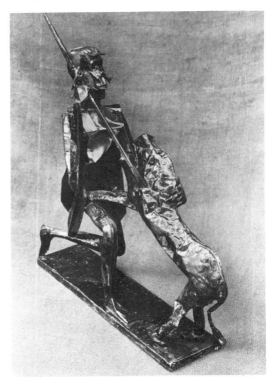

Francis Ndwiga. Photo Richard E. Beatty

99

Kenya National Theatre 1967;* galleries in Nairobi since 1967. Works displayed Norfolk Hotel, Tropicana and Oriental Restaurants, Nairobi; Outspan Hotel, Nyeri, Kenya; Atlas Insurance Company, Nairobi; Namanga Hotel, Kenya; College Inn Hotel, Loreto Convent, Nairobi; Society National of Canada, Montreal; BAT Company, Ghana. Paintings owned by Kenya Cabinet Ministers and Chief of Police. Member Kenya Art Society. Designed cartoons and illustrations and graphics in numerous publications; 1971 East African Wild Life Society Calendar; commissioned by *Reader's Digest*. Box 44056, Nairobi. Paintings in an expressionist mode; thickly layered paint.

Njau, Elimo. Born Marangu, Tanzania 1932. Attended Makerere School of Fine Arts 1952–57. Taught Makerere Demonstration School 1962–63; University of Dar es Salaam Department of

Edward Njenga

Theatre Arts 1965–69; Assistant Director Sorsbie Gallery 1963–64; Director Kibo Art Gallery since 1965; Director Paa-ya-Paa Gallery since 1966; Director Sanaa Zetu Gallery since 1970. Exhibited Uganda Museum 1960;* Sorsbie Gallery; Chemchemi Cultural Centre; Kibo Art Gallery; Paa-ya-Paa Gallery. Works displayed Cathedral of the Martyrs, Marang'a; Fort Hall Memorial Chapel, Kenya; Kibo Art Gallery; National Bank of Tanzania, Dar es Salaam, Tanzania; St. Francis Chapel, Makerere University. British Council Scholarship to Britain, Germany, Sweden 1961. Organized "Let the Children Paint", Makerere Demonstration School, to tour East Africa, Germany 1962–63. C/o Paa-ya-Paa Gallery, Box 9646, Nairobi or Sanaa Zetu Gallery, Box 798, Moshi, Tanzania. Painter.

Njau, Rebeka. Born Kanyariri, Kikuyu, Kenya. Attended Makerere University College. Taught Kampala; Headmistress, Nairobi Girls Secondary School 1964–68. Exhibited Paa-ya-Paa Gallery 1968,* '69,* '70;* National Museum, Dar es Salaam 1969;* Zambia Arts Festival 1969; Algiers Festival 1969* (designed costumes for National Dance Troupe of Tanzania); "Africa Creates", New York 1973. Uganda Drama Festival award for play *The Scar* 1960; East African Literature Bureau annual novel competition prize, *Alone With the Fig Tree* 1964. C/o Paa-ya-Paa Gallery, Box 9646, Nairobi or Sanaa Zetu Gallery, Box 798, Moshi, Tanzania. Batiks, tie-dyed cloth, pottery.

Njenga, Edward. Born Kiambu, Kenya 1932. Attended Posts and Telegraphs Training School, Mbagathi, Kenya 1950–52; Woodbrooke College, Birmingham, England 1961–62; Academy of Art, Hanover 1971–72. Social worker, Friends Centre, Ofafa 1956–61, 1963–68; Director, Eastleigh Community Centre, Nairobi 1968–70. Exhibited New Stanley Gallery 1964,* '66;* Paa-ya-Paa Gallery 1968;* Gallery Africa 1970;* Goethe Institute, Nairobi 1971. Designed Christmas cards and notes for Eastleigh Community Centre. C/o Eastleigh Community Centre, Box 12330, Nairobi. Terra-cotta figurines, often several in a group with amusing details, expressive features.

Njuguna, George. Born Dagoretti, Kenya. Worked with transport company, Uganda and in Mombasa 1966. Exhibited Gallery Africa 1970.★ Good feel for detail and expression in terra-cotta sculptures.

Nkata, Livingstone. Born Mukono, Uganda 1939. Attended University of Nairobi 1960–62; Makerere School of Fine Arts 1963–65; Pratt Institute, Brooklyn, New York 1967–68. Taught Lugazi, Uganda 1965–68; Education Officer, Uganda Museum since 1969. Exhibited Nommo Gallery 1965, '69;★ Uganda Museum 1966, '71.★ Member Uganda Arts Club. C/o Uganda Museum, Box 365, Kampala. Painter, sculptor, printmaker.

Nnaggenda, Francis X. Born Bukumi, Uganda 1936. Attended Ecole ABC de Paris 1959–63 (by correspondence); apprenticed in Switzerland 1963; in Germany 1963 (with Siegfried Fricker, Jestetten am Rhein); Technical Institute, Kampala 1959; Academy of Fine Arts, Munich 1964–67. Tutorial Fellow, University of Nairobi 1968–69; Research Assistant, Institute of African Studies, University of Nairobi 1970–72. Exhibited Notre Dame University, U.S.A.; State Museum, Munich 1965; Nommo Gallery 1967;★ City Hall, Nairobi 1968;★ Kisumu Arts Festival 1968; Kenya-American Womens Association, City Hall, Nairobi 1969; Willoughby Hall, Nairobi University 1969;★ Danish Embassy, Nairobi 1970★ (in honour of royal visit); USIS Auditorium, Nairobi 1970;★ Kenya National Museum 1974. Second prize, Munich University 1967. Box 14246, Mengo, Uganda or c/o Institute of African Studies, National Museum, Box 30197, Nairobi. Sculptures in welded metal and wood, often over 6 feet tall; uses found objects, vivid expressions. Paintings in post-cubist mode.

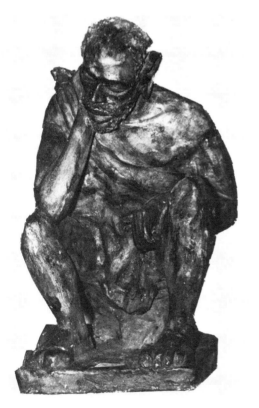

George Njuguna

Francis Nnaggenda. Photo David MacDougall

101

Ntiro, Sam. Born Machame, Kilimanjaro, Tanzania 1923. Attended Makerere School of Education 1944–47; Slade School of Fine Art, London (Colonial Development and Welfare Fund Scholarship) 1952–55; Institute of Education, University of London 1956. Taught Makerere School of Fine Arts (Acting Head) 1956–58; 1960–61; Carnegie grant to U.S. 1959–60. High Commissioner for Tanganyika to London 1961–64; Commissioner of Culture, Dar es Salaam 1962–74; Minister of External Affairs and Defence, Dar es Salaam 1964. Exhibited "Africa Creates", New York 1973 and numerous other exhibitions. Works displayed Commonwealth Institute, London; Makerere Art Gallery; The Museum of Modern Art, New York; Chase Manhattan Bank, New York. Chairman, Tanzania Crafts Council 1964, '67, '70; Chairman, Tanzania Arts Society 1964, '67; Chairman, Society of East African Artists since 1969; General Secretary, World Council of Craftsmen, New York 1964. C/o Ministry of Education, National Culture and Antiquities Division, Box 9121, Dar es Salaam. Paintings of rural scenes, lyrical feeling for patterns and large areas of colour.

Okello, Gard. Born Lira, Uganda 1942. Attended

University of Nairobi 1963–67; Makerere School of Fine Arts 1967–68. Taught Lango College, Uganda. Exhibited New Stanley Gallery 1967;★ National Theatre, Kampala 1969; Hotel Intercontinental (Nairobi Galleries) 1969,★ '70,★ '71;★ Gallery Africa 1970, '71. First prize, Rowney Art Competition, East Africa 1959; award, Gebrauchsgraphik, International Advertising Art 1971. Box 82, Lira, Uganda or c/o Department of Design, University of Nairobi, Box 7062, Nairobi. Printmaker, batiks, sculptor.

Omare, Flora Aulogot. Born Kidera Village, Busia, Kenya 1926. Attended Mumias Girls School 1942; began sculpting 1942. Exhibited Kericho Town Show, Kenya 1944; Nairobi Show 1948, '70; Bungoma Town Show, Kenya 1955; Somalia Trade Fair 1960; Kakamega Town Show, Kenya 1968; Gallery Africa. Sculpture presented to Princess Margaret. Kidera Village, South Teso Location, Busia District, Kenya, or Box 187, Tororo, Uganda. Sculpture in realistic, doll-like figurines.

Ong'esa, Elkana. Born Kisii, Kenya 1944. Attended Makerere School of Fine Arts and Education 1967–71. Taught Muma Primary School, Kisii

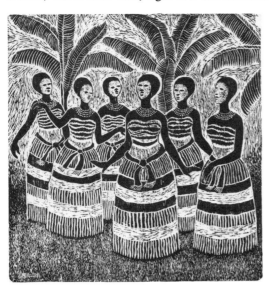

Gard Okello, "Baganda Dancers"

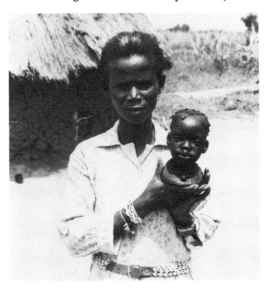

Flora Omare. Photo W. G. Adams

1967; research assistant, Kisii 1968–69; research into traditional Kisii soapstone carving 1969–71; taught Kisii Secondary School since 1971. Exhibited Freedom From Hunger Campaign, Nairobi 1965; Uganda Museum 1970; Bank of Uganda, Kampala 1970. Works displayed Makerere Art Gallery; Central Bank of Uganda; Jamhuri Gardens, Kisii. First prize for sculpture, National Freedom From Hunger Campaign; Margaret Trowell Award for painting 1968, '69; research grant, University of Nairobi 1969–71; post-graduate scholarship, University of Nairobi 1971–72. C/o Kisii Soapstone Products, Box 316, Kisii, Kenya. Soapstone sculptures, rounded and polished, ovoid shapes juxtaposed against spaces; paintings in modern styles.

Owiti, Hezbon Edward. Born Siaya District, Nyanza, Kenya 1946. Attended University of Ibadan, Lagos 1965 (6-month scholarship, Far-field Foundation, N.Y.); artist-in-residence, Sussex University, England 1968; gallery assistant, Chemchemi Cultural Centre 1963–65. Exhibited Chemchemi Cultural Centre 1965;* Mbari Mbayo, Oshogbo, Nigeria; Mbari Mbayo Yaba, Lagos; Mbari Mbayo, Ibadan, 1966;* Camden Art Centre, London 1968; Sussex University, England 1968;* '71;* Dar es Salaam 1970;* III Biennale International, Graphics, Krakow 1970; Ohio 1971;* Addis Ababa 1971;* USIS Auditorium, Nairobi 1972. In newspapers in East and West Africa; *African Arts* magazine; *Contemporary Art in Africa*, Uli Beier. Box 12953, Nairobi. Lithographs in lively expressionism; paintings similar and densely coloured; fabric design.

Rocco, Giselle. Born Paris 1892. Attended private school, Paris 1902; Chapin School, New York 1906–08. Exhibited New Stanley Gallery 1968.* Works displayed Grand Palais, Paris. Member Apprix aux Artists, President 1914–18, Paris. Box 38, Naivasha, Kenya. Sculptor, painter.

Rose, Sister Mary Lou. Born Detroit, Michigan, U.S.A. 1929. Entered Maryknoll Sisterhood, N.Y. 1947. B.S. in Home Economics 1954.

Hospital dietician, Kansas City 1954–58. To Tanzania 1958. Taught Kilakala Secondary School 1958–66. Returned U.S. 1966. Masters of Fine Arts 1969. Returned Tanzania 1969. Exhibited Paa-ya-Paa, Kibo Art Gallery 1970; National Museum Dar es Salaam 1972. Painter, illustrator.

Salyeem, Thomas C. Born Kilimanjaro, Tanzania 1943. Attended Makerere School of Fine Arts and Education 1967–72. Taught Arusha Karafu Extended Primary School 1965–67. Works displayed Makerere Art Gallery. C/o Institute of Education, Box 7062, Makerere University, Kampala. Paintings use distinctive patterns rhythmically; vibrating colours.

Sanders, Thelma. Born Paris; to Nairobi 1951. Attended St. Martin's School of Art, London; Central School of Art, London 1964. Exhibited Donovan Maule Theatre Club, Nairobi; New Stanley Gallery; Gallery Watatu. Works displayed Keekorok Lodge, Masai Mara Game Reserve, Samburu Lodge, Uaso Nyiro Lodge, Kenya. Box 3761, Nairobi. Woodcuts with elongated figures in soft earth tones.

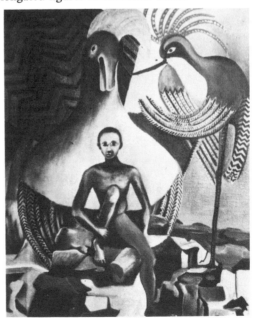

Elkana Ong'esa, "Dream"

Semiti, Mathias. Exhibited "Africa Creates", New York 1973. Banana fibre mosaics.

Sempagala, George Willison. Born Kampala 1940. Attended Uganda Technical College 1959–60; Abuja Training Pottery, Nigeria (with Michael Cardew) 1960–62; English pottery, British Council Scholarship (with Bernard Leach) 1969–71. Founder Namanve Pottery, Uganda. Exhibited J. K. Randle Hall, Lagos 1962;★ Uganda Museum 1963;★ Craft Potters Show, London 1965; Beaford Centre, North Devon, England 1970. Box 19072, Kasangati, Uganda. Glazed pottery with classic sense of form and usefulness.

Sempangi, F. Kefa. Born Kawuna, Uganda 1939. Attended Makerere School of Fine Arts 1963–67; Royal College of Art, London 1967–70; Vre University, Amsterdam 1970–74 (continued by correspondence). Taught Makerere School of Fine Arts since 1971. Exhibited Nommo Gallery 1967;★ African Centre, London 1968; Camden Art Centre, London 1969; Vre University 1970;★ Royal College of Art 1970; York University, England 1970; Oxford University 1970. Works displayed Lee Abbey, London; Cement and Concrete Association, Slough; Uganda Teachers Association, Kampala; Mitchell Hall, St. Francis Chapel, Makerere University; Senior Commons Room, International Students Office, Vre University. Illustrated *East Africa Series*, Silverleaf Press, Wimbledon, England. C/o Department of Fine Arts, Makerere University, Box 7062, Kampala. Sophisticated facility in several media; surrealistic portraiture, sombre abstract paintings, found objects and cast bronze in sculpture.

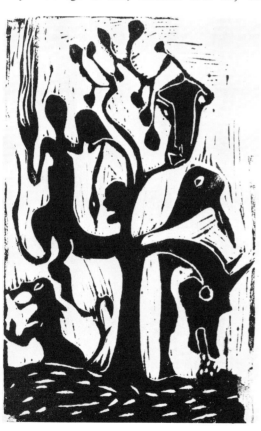

Hezbon Owiti

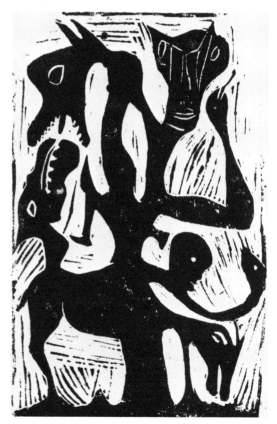

Hezbon Owiti

104

Senyagwa, Gideon A. L. Born Mhembe, Mpwapwa District, Tanzania 1940. Attended Makerere School of Fine Arts and Education 1964–69. Taught Tambaza Secondary School, Dar es Salaam 1968–70; assistant headmaster since 1970. Works displayed New Hall, Makerere University. In *World Encounter.* C/o Tambaza Secondary School, Box 20576, Dar es Salaam. Painter.

Shah, Tara. Born Kenya. Exhibited Gallery Watatu 1970.* Painter, batiks.

Somola, John. Born Tanzania. Attended Makerere School of Fine Arts. Taught Tabora Secondary School, Tanzania 1953–60. Exhibited Imperial Institute, London 1957; Dar es Salaam 1963. Painter.

Sserulyo, Ignatius. Born Bweyo, Masaka District, Uganda 1937. Attended Makerere School of Fine Arts and Education 1960–66. Taught King's College, Budo, Uganda 1964–65; St. Mary's College, Kisubi, Uganda 1964; Makerere College Demonstration School 1966–67; Nyakasura School, Uganda 1968; Kibuli Secondary School, Kampala since 1969. Exhibited Nile Centenary Festival, Jinja, Uganda 1962; Commonwealth Institute, London 1965; National Museum of Wales, Cardiff 1965; Nommo Gallery 1965, '66; Savage Gallery, London 1965; Camden Art Centre, London 1969; Irving Trust Co., New York 1969; Expo '70, Osaka, Japan; Salisbury, Rhodesia; Whitechapel Gallery, London; State Museum, Munich. Works displayed St. Francis Chapel, Northcote, Hall, Makerere Art Gallery, Mary Stuart Hall, Makerere University; National and Grindlay's Bank, Fenchurch Street, London; Bank of Uganda, Uganda Prison Department, Kampala; WHO Headquarters, Kinshasa. Margaret Trowell Award 1962; Honorarium, U.S. Embassy 1968; first prize, Esso Competition 1969. Organized first Art and Crafts Exhibition, Nyondo Teachers Training College, Mbale, Bugisu, Uganda 1966. In *Dictionary of African Biography*, London; *Roho* magazine, Kampala; Makerere Handbook and Catalogue; "Art in Uganda"; *Uganda Argus; Daily Nation;* illustrated Kisubi Tombs booklet; Chemistry Reader (cover); Irving Trust Company 1969 Annual Report; *Africa's Contemporary Art and Artists*, Brown. C/o Kibuli Secondary School, Box 4216, Kampala. Paintings have movement and rhythm expressed in patterns of figures, local scenes, bright colours. Sculpture.

Sweverta, Peter. Born Bena, Njombe, Tanzania. Attended primary School Standard V. Mission centre gardener 1964–66. Attended Ifunda Technical College 1966–70. Assistant instructor Ifunda Technical College 1970. Worked Moonlight Studio, N.A.T. Gallery, Dar es Salaam. Works displayed N.A.T. Gallery (bust of Julius Nyerere). Sculptor.

Tingatinga, Eduardo. 1937–72. Born Mindu Village, Tunduru, Rovuma Region, Tanzania. Taught Msasani Workshop, Dar es Salaam. Exhibited National Museum, Dar es Salaam 1972. Painter.

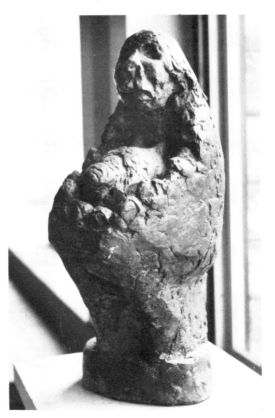

Kefa Sempangi, "Musoke's Wife"

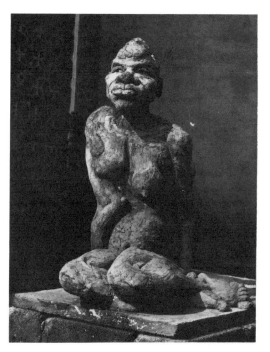

Ignatius Sserulyo, "Woman"

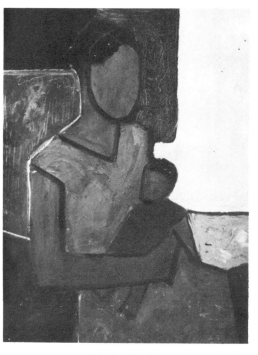

Sefania Tunginie, "Mother and Child"

Tunginie, Sefania. Born Njombe District, Tanzania 1931. Attended Makerere School of Fine Arts 1950–52; Camberwell, London 1959–62; Indiana University, Bloomington, U.S.A. 1965–66. Taught Mpwapwa Teachers Training College, Tanzania 1953–59; University of Dar es Salaam 1964–67; Principal, Teachers Training College, Butimba-Mwanza, Tanzania 1968; Principal, Teachers Training College, Dar es Salaam 1969–70; Director, Teacher Education, Dar es Salaam since 1971. Exhibited USIS Gallery, Dar es Salaam 1964.★ C/o Ministry of National Education, Box 9121, Dar es Salaam. Painter, printmaker.

Waite, Jony. Born Los Angeles 1936; to Nairobi 1962. Attended University of Hawaii 1955–56; University of California 1956–58; Institute des Artes de San Miguel de Allende, Mexico 1956; studied Suma ink technique, Japan 1958–60; studied classical Chinese painting, Hong Kong 1958. Co-director, Gallery Watatu since 1970. Works displayed Nilestar Tours offices, Nairobi, London; Watamu Beach Hotel, Malindi, Kenya; Nairobi Hilton Hotel; Norfolk Hotel, Nairobi. In Japanese art books and yearbooks. C/o Gallery Watatu, Box 21130, Nairobi. Expressive, economical line drawings; dramatic paintings, textile design and murals.

Wanjau, Samuel. Born near Nyeri, Kenya 1936. Worked Gikomba Kamba Carving Centre, Nairobi 1961–67; apprenticed to Elimo Njau, Kibo Art Gallery 1968–71. Exhibited Kibo Art Gallery; Paa-ya-Paa Gallery 1970, '71;★ Sweden; U.S.A.; Zambia; Italy; Israel; Switzerland. C/o Paa-ya-Paa Gallery, Box 4496, Nairobi. Sculpture shows facility in figural form, experimentation in size and media.

Wasswa, Katongole Kakooza. Lives Kasubi, Hoima Road, Mile 3, Uganda. Exhibited Gallery Africa 1970. P.O. Box 16195, Wangegeya, Kampala. Painter.

Waziri, Juma. Born Tanga, Tanzania 1931. Attended Makerere School of Fine Arts 1951–53;

Beit-el-Ras Teachers Training College, Zanzibar 1949–50. Taught Tanga Secondary School 1954–57; Administrative Officer, Tanga 1957–62; Regional Commissioner, Mbeya Region, Tanzania 1963–64; Ambassador of Tanzania to Peking 1965–66; Regional Commissioner, Tabora, Tanzania since 1969. Exhibited Tanga Secondary School 1954, '55, '56. Works displayed Makerere Art Gallery. Box 25, Tabora, Tanzania. Painter, sculptor.

Webbo, Elfas. Born Kakamega District, Bunyoro Location, Kenya 1937. Attended Makerere School of Fine Arts and Education 1959–63; 1966–69. Taught Mwihila Secondary School, Kenya 1963; Butere Teachers Training College, Kenya 1964–66; Siriba Teachers College, Kenya 1969; Kenyatta College 1969–70. Art Education Inspector for Kenya Schools since 1970. Exhibited Paa-ya-Paa Gallery 1966; University of Nairobi. Works displayed Makerere Art Gallery. C/o Ministry of Education, Box 30040, Nairobi. Painter.

Sefania Tunginie, "The Prophet Elijah"

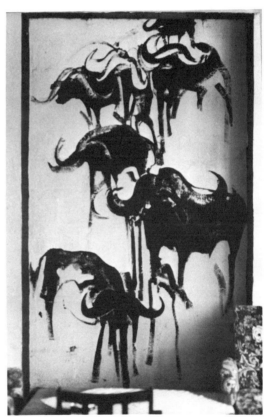

Jony Waite. Photo Harald Nickelsen

Bibliography

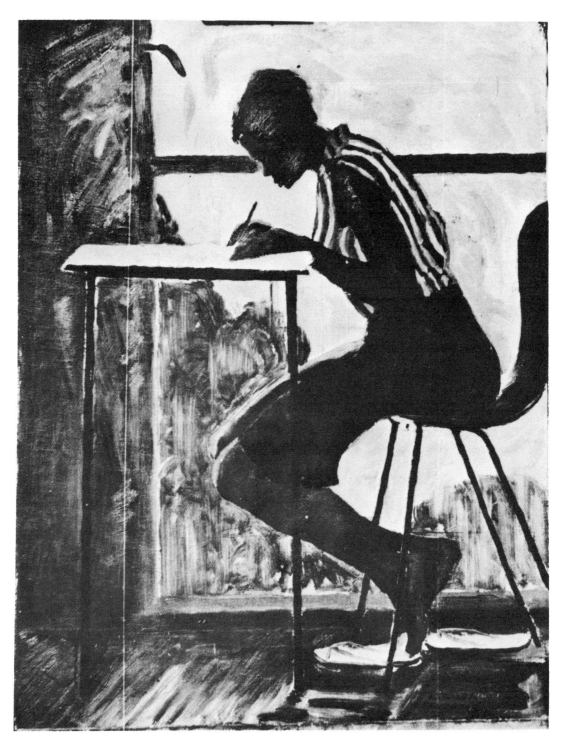

Francis Msangi, "Work in the Library"

Bibliography

Adamson, Joy, *The Peoples of Kenya*, Collins and Harvill Press, London, 1967

Allen, B. James de Vere, "Doors: Classic Art Form", *Daily Nation*, 5 October, 1969

——, *Lamu*, Kenya Museum Society, Nairobi, 1972

——, "Lamu: Its Arts and Crafts", introductory essay, exhibition catalogue, Nommo Gallery, Kampala, 1969

Allison, Philip, *African Stone Sculpture*, Lund Humphries, London, 1968

d'Azevedo Warren, ed., *The Traditional Artist in African Societies*, Indiana University Press, Bloomington, 1972

Barton, F. R., "Zanzibar Doors", *Man*, No. 63, 1924

Beier, Ulli, *Contemporary Art in Africa*, Pall Mall Press, London, 1968

Bennet-Clark, M. A., "A Mask from the Makonde Tribe in the British Museum", *Man*, No. 117, 1957

Bon, Irmgard, "Masken und Plastiken der Makonde in Tanganyika", *Neues Africa*, Nov. 1961

Brown, Evelyn S., *Africa's Contemporary Art and Artists*, Harmon Foundation, N.Y., 1961

Christol, F., *l'Art Dans l'Afrique Australe*, 1911

Chubb, E. C., "East African masks and an Ovambo sheathed knife", *Man*, No. 110, 1924

Cole, Sonia, *The Prehistory of East Africa*, Penguin, London, 1954

Cory, H., *African Figurines*, Faber & Faber, London, 1956

——, "Figurines Used in the Initiation Ceremonies of the Nguu of Tanganyika Territory", *Africa*, 148, Oct. 1944

——, "Sumbwa Birth Figurines", *Journal of the Royal Anthropological Institute*, 91(1), 1961

Crowley, Daniel J., "The Contemporary-Traditional Art Market in Africa", *African Arts*, Autumn 1970

Dick-Read, Robert, *Sanamu, Adventures in Search of African Art*, Rupert Hart-Davis, London, 1964

Dictionary of African Biography, Macmillan, London

Earl, E. R., "African enterprise (Kamba woodcarvers)", *East African Annual*, 1958–59

East Africa Women's League, *They Made It Their Home*, East Africa Women's League, Nairobi, 1962

East African Institute of Social and Cultural Affairs, *East Africa's Cultural Heritage*, Contemporary Monograph Series No. 4, East African Publishing House, Nairobi, 1966

Elkan, W., "The East African Trade in Woodcarvings", *Africa*, 28, 1958

Fagg, William, *La Sculpture Africaine*, Fernand Hazan, Paris, 1958

——, *Tribes and Forms in African Art*, Tudor Publishing Co., N.Y., 1965

——, and Margaret Plass, *African Sculpture*, Dutton, Studio Vista Ltd., London, 1964

Fouquer, Roger, *La Sculpture Moderne des Makondés*, Nouvelles Éditions Latines, Paris, 1971

Gaskin, L. J. P., with Guy Atkins, *A Bibliography of African Art*, International African Institute, London, 1965

Gillman, C., "An annotated list of ancient and modern indigenous stone structures in Eastern Africa", *Tanganyika Notes and Records*, 1944

Harding, J. R., "'Mwali' dolls of the Wazaramo", *Man*, No. 83, 1961

Hartwig, Gerald W., "A Historical Perspective of Kerebe Sculpturing—Tanzania", *Sonderdruck aus Tribus*, Veröffentlichungen des Linden-Museums, No. 18, Stuttgart, Aug. 1969

Hausenstein, William, *Barbaren und Klassiker*, Verlag R. Piper & Co., Munich, n.d.

Hermann, Ferdinand, and Paul Germann, *Beiträge zur Africanischen Kunst*, Akademie Verlag, Berlin, 1958

Hirst, Terry, "New Art From Kenyatta College", *African Arts*, Summer 1971

Hobley, C. W., *Ethnology of the Akamba and Other East African Tribes*, Cambridge, 1910

Holy, Ladislav, *The Art of Africa: Masks and Figures from Eastern and Southern Africa*, Paul Hamlyn, London, 1967

Instituto de Investigaçao Cientifica de Moçambique, eds., "Wood Sculptures of the Makonde People", (Album), Lourenço Marques, 1963

Intermediate Technology Development Group, Ltd., and Maxwell Stamp (Africa), Ltd., *Report on the Development of Cottage Industries Based on Sisal, Wood and Metal Working, and Leather in Kenya*, 1969

Kareithi, Peterson Munuhe, *Let the Child Create*, Equatorial Press, Nairobi

Kariara, Jonathan, "Kibo Art Gallery", *Tanganyika Notes & Records*, No. 64, March 1965

Kasfir, Sidney, "Francis Nnaggenda", *African Arts*, Autumn, 1969

Kiewe, Heinz Edgar, with Michael Biddulph, *Africa: Make Them Craftsmen*, Oxford University Press, London, 1969

Kirkman, J. S., *The Arab City of Gedi, excavations at the great mosque: architecture and finds*, Oxford University Press, London, 1954

——, "Excavations at Kilepwa", *Antiquaries Journal*, Vol. xxxii, 1952

——, *Men and Monuments on the East African Coast*, Lutterwood Press, London, 1964

Kjersmeier, *African Negro Sculptures*, A. Zwemmer, London; Wittenborn, Schultz, Inc., N.Y., 1947

Leakey, M. D., "Report on the Excavations at Hyrax Hill, Nakuru, Kenya Colony, 1937–38"

——, and Others, "Dimple-based pottery from central Kavirondo, Kenya Colony, Coryndon Memorial Museum", (Occ. Papers), Nairobi

Leiris, Michel, and Jacqueline Delange, *African Art*, Thames & Hudson, London, 1968

Leuzinger, Elsy, *Art of the World: Africa, The Art of the Negro People*, Methuen, London, 1960

Lindblom, K. Gerhard, *The Akamba in British East Africa*, Appelbergs Boktryckeri Aktiebolag, Uppsala, Sweden, 1920

Lugira, Alois Muzzanganda, *Ganda Art*, Osasa Publication, Kampala, 1970

Maloba Gregory, (Margaret Trowell, ed.), *Modelling*, Longman, London, 1954

Maquet, Jacques J., *Afrique, Les Civilisations Noires*, Horizons de France, 1962

Marshal, Anthony D., *Africa's Living Arts*, Franklin Watts, Inc., N.Y., 1970

Miller, Judith von Daler, "East African Art Today", *Arts Review*, Vol. xxvi, London, 1974

Ministry of Culture and Community Development, *Uganda Crafts*, Kampala, 1965

Mount, Marshall Ward, *African Art, The Years Since 1920*, Indiana University Press, Bloomington, 1972

Okpaku, Joseph O., ed., *New African Literature and the Arts*, The Third Press, N.Y., 1974

Ng'weno, Hilary, "Letter from Nairobi", *African Arts*, Winter 1968

Njau, Elimo, *The Fort Hall Murals*, Kibo Art Gallery Fund, Nairobi, 1963

——, "Kibo Art Gallery", *Tanganyika Notes & Records*, No. 64, March 1965, Tanganyika Society

Ntiro, Sam, "East African Art", *Tanganyika Notes & Records*, 1963, and *Journal of the Royal Society of Arts*, May 1963

Ogot, Bethwell A., *History of the Southern Luo*, East African Publishing House, Nairobi, 1967

Owiti, Hezbon Edward, "Painting is a Creation", *African Arts*, Spring 1969

Parrinder, Geoffrey, *African Mythology*, Paul Hamlyn, London, 1967

Plumer, Cheryl, *African Textiles: An Outline of Handcrafted Sub-Saharan Fabrics*, Michigan State University, East Lansing, 1971

Poznansky, Merrick, "A stone carving from Angolom, Uganda", *Man*, No. 63, Sept. 1963

Prins, A. H. J., *Coastal Tribes of the North-Eastern Bantu*, International African Institute, London, 1952

Rachewiltz, Boris de, *Introduction to African Art*, Aldo Martello Editore, Milan; John Murray, London, 1966

Radin, Paul, ed., with Elinore Marvel, *African Folktales and Sculpture*, Pantheon Books, Inc., N.Y., 1952

Reckling, Walter, "Handwerk und Kunst der Wazeramo", *Koloniale Rundschau*, 33, 1942

Robbins, Warren, *African Art in American Collections*, Praeger, N.Y., Washington, London, 1966

Routledge, W. S., "An Akikuyu Image", *Man*, No. 6, 1906

——, *With a Prehistoric People: The Akikuyu of British East Africa*, London, 1910

Sekintu, C. M., and K. P. Wachsmann, "Wall Patterns in Hima Huts", Uganda Museum, (Occ. Papers), 1956

Shepherd, David, *An Artist in Africa*, Collins Press (in association with Tryon Gallery), London, 1969

Shore, Herb and Megchelina, *The Art of Makonde*, Thames & Hudson, London, 1970

——, *Makonde: A People and Their Art*, East African Publishing House, Nairobi, 1970

Shore-Bos, Megchelina, "Modern Makonde: Discovery in East Africa", *African Arts*, Autumn 1969

Schmalenbach, Werner, *African Art*, Macmillan, N.Y., Holbein-Verlag, Basel, 1928

Smith, Mrs. D. Gregory, "Hand-spinning and weaving in Nyanza Province, Kenya", *East African Annual*, 10, 2, Oct. 1944

Stout, J. Anthony, *Modern Makonde Sculpture*, Kibo Gallery, Nairobi, 1966

Stuhlmann, F., "Handwerk und Industrie in Ostafrika", *Abhandlungen des Hamburgischen Kolonialinstitut*, I., Hamburg, 1910

Syracuse University School of Art, *Modern Makonde Sculpture*, catalogue, Program of East African Studies, 1969

Thompson, Ralph, *An Artist's Safari*, Collins Press (with Tryon Gallery, Ltd.), London, 1970

Tracey, Andrew, "Kamba Carvers", *African Music*, II, 1960

Trowell, Margaret, *African Arts and Crafts*, Longmans, Green & Co., London, 1937

——, *African Design*, Faber & Faber, London, 1960

——, and Hans Nevermann, *African and Oceanic Art*, Harry N. Abrams, Inc., N.Y., London, n.d.

——, *African Tapestry*, Faber & Faber, London, 1957

——, *Art Teaching in African Schools*, Longmans, London, 1952

——, "Development of art and indigenous crafts in Uganda", *Uganda Teachers' Journal*, May 1940

——, "Modern African Art in East Africa", *Man*, No. 47, 1947

——, "Some royal craftsmen of Buganda", *Uganda Journal*, Jan. 1941

——, and Klaus Wachsmann, *Tribal Crafts of Uganda*, Oxford University Press, London 1953

Vajda, L., "Human and Animal Plastic Figures from the Kilimanjaro Region", *Neprajzi Ertesito*, XXXVIII, Budapest, 1955

von Daler, Judith, "A New Gallery in Kampala", *African Arts*, Autumn 1970

——, "Contemporary Art in East Africa", *Kenya Past and Present*, Nairobi, May 1972

Willett, Frank, *African Art*, Thames & Hudson, London, 1971

Wilson, Monica, "Traditional Art Among the Nyakyusa", *South African Archaeological Bulletin*, 19 (75), 1964

Wingert, Paul S., *The Sculpture of Negro Africa*, Columbia University Press, N.Y., 1950

World Crafts Council, *African Crafts Survey*

Index

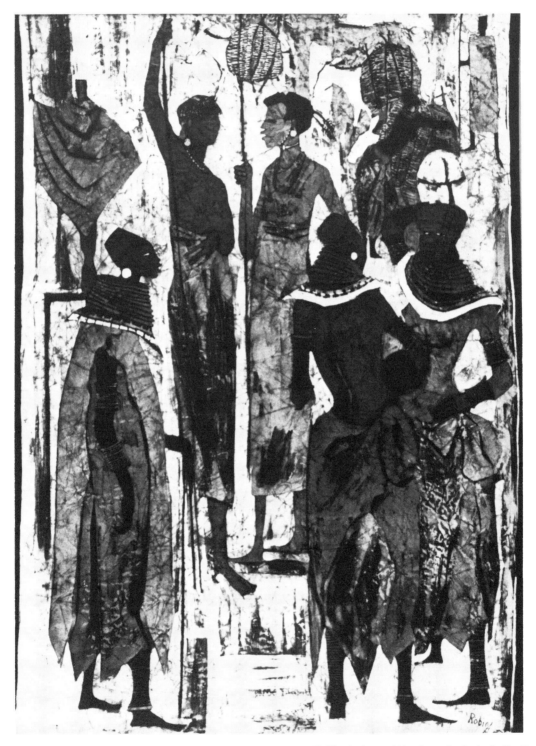

Robin Anderson, "Samburu Gathering". Batik

Index

124